From Your Friends at Engineering Services

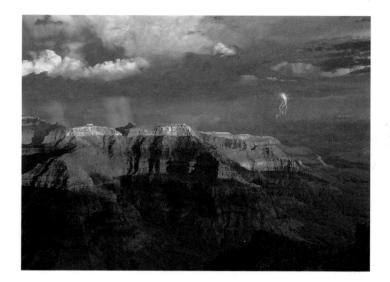

ARIZONA

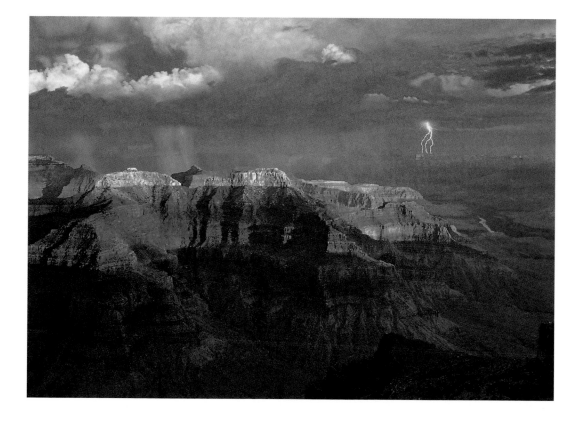

WHITECAP BOOKS
VANCOUVER / TORONTO / NEW YORK

Text by Tanya Lloyd
Edited by Elaine Jones
Photo editing by Antonia Banyard
Proofread by Lisa Collins
Cover and interior design by Steve Penner
Desktop publishing by Susan Greenshields
Printed and bound in Canada

Canadian Cataloguing in Publication Data

Lloyd, Tanya, 1973–

 Arizona

 ISBN 1-55110-865-8

1. Arizona—Pictorial works. I. Title.
F812.L66 1999 979.1'053'0222 C98-911018-4

The publisher acknowledges the support of the Canada Council and the Cultural
Services Branch of the Government of British Columbia in making this publication
possible. We acknowledge the financial support of the Government of Canada through
the Book Publishing Industry Development Program for our publishing activities.

**For more information on the America Series and other Whitecap Books
titles, please visit our web site at www.whitecap.ca.**

Arizona is a land of surprises—lush flora hidden along a canyon bottom, ruins camouflaged in the limestone wall of a cliff, the sudden glimpse of a hot pink cactus flower, blooming against the dry earth of the desert. When visitors think of Arizona, they think immediately of the Grand Canyon, one of the seven natural wonders of the world and an awesome barrier through the northwest corner of the state. While this may be the most breathtaking, however, it is only one of hundreds of natural and historical sites throughout the Grand Canyon State.

Two thousand years ago, native peoples were already planting Arizona's river valleys with crops. They built pit houses, then cliff dwellings, then the simple yet stunning pueblos that now draw thousands of visitors. Petroglyphs and pictographs, preserved in the dry desert air, remind us of life in a different time. In no other region is the link between the past and the present so obvious to the average visitor. From the amazing construction of Montezuma Castle to the preserved moonscape of Meteor Crater, the landscapes of Arizona afford glimpses of the past.

Those drawn to the state by the ruins, the canyons, or the desert parks are met with yet another surprise—the thriving culture of Arizona's cities. Visitors to Phoenix find themselves in a sophisticated metropolis, filled with shops, cafés, and art galleries. They can wander from the imposing state capital building to the shopping district of Scottsdale, or from the sprawling university campus to the exhibits of the Heard Museum. Tucson offers a completely different atmosphere, where the Wild West scenes of Old Tucson exist side-by-side with the technology of the Kitt Peak National Observatory.

Each corner of the state contributes a unique perspective on Arizona's history. From the San Francisco Peaks to the Colorado River flowing in the depths of the Grand Canyon, Arizona is a land of spectacular and varied geography, people, and cultures.

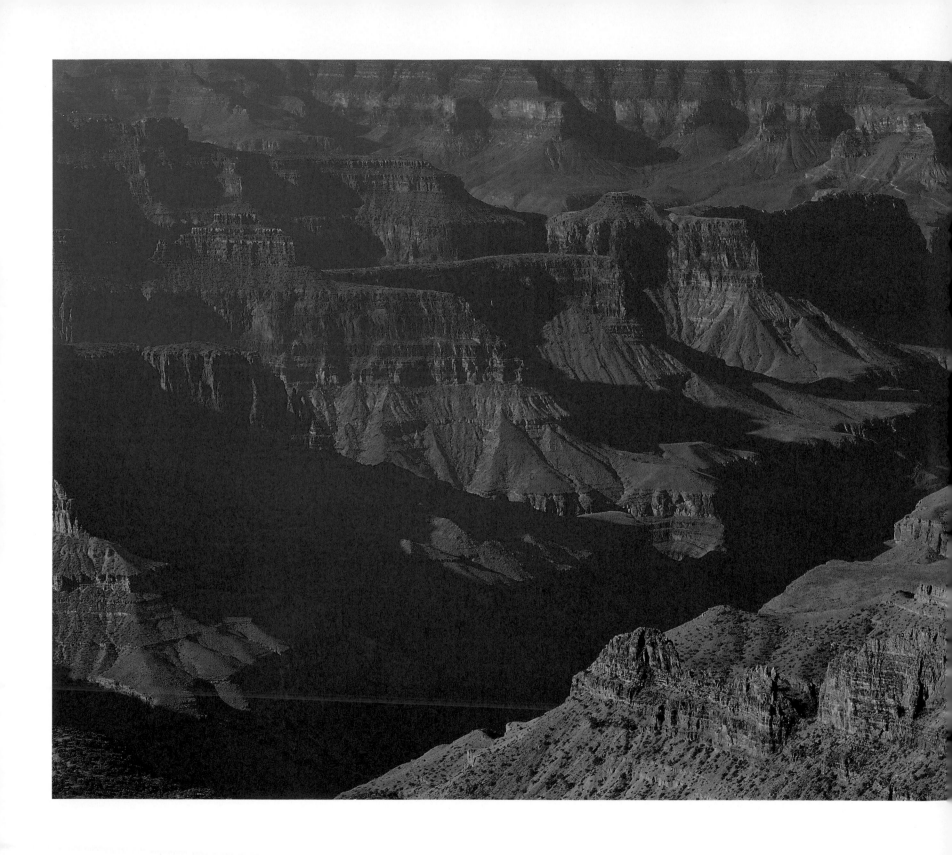

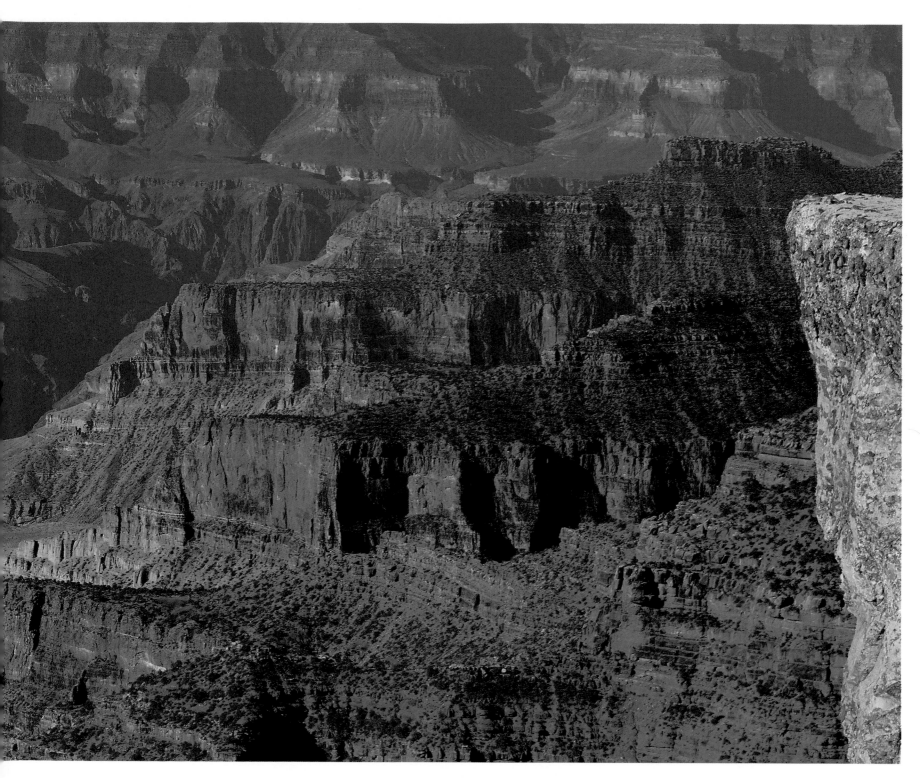

One of the seven natural wonders of the world, the Grand Canyon is a mile deep in places, and stretches for 277 miles along the Colorado River. Point Sublime is on the north rim, just a few miles from the Grand Canyon Lodge.

One of 300 species of birds that live year-round in Arizona, this gila wood-pecker enjoys a cactus flower snack.

OPPOSITE —
Commemorating pioneer life in Arizona, Pipe Springs National Monument was once a Mormon ranch. The park staff maintains the ranch's orchards and demonstrates baking, blacksmithing, and weaving to summer visitors.

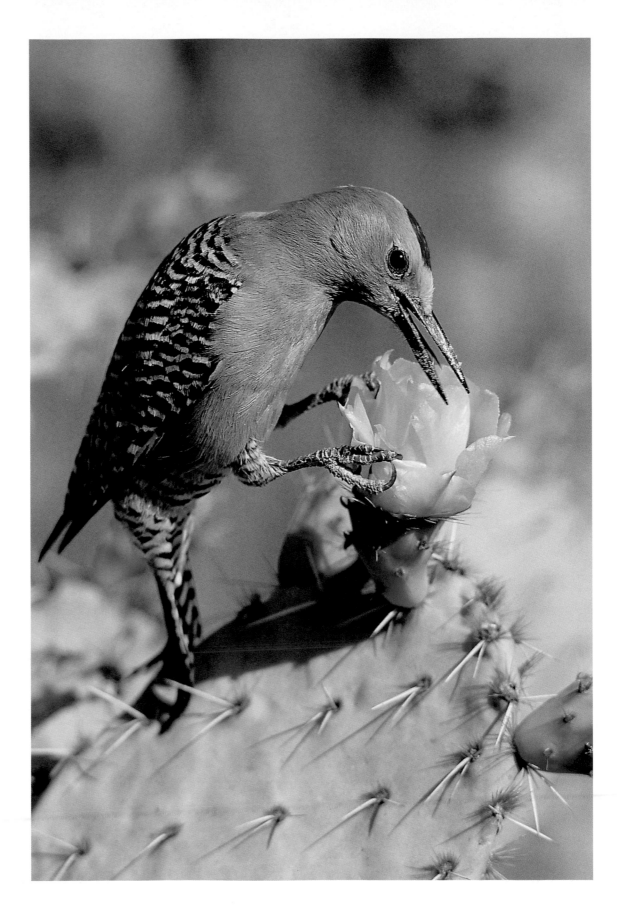

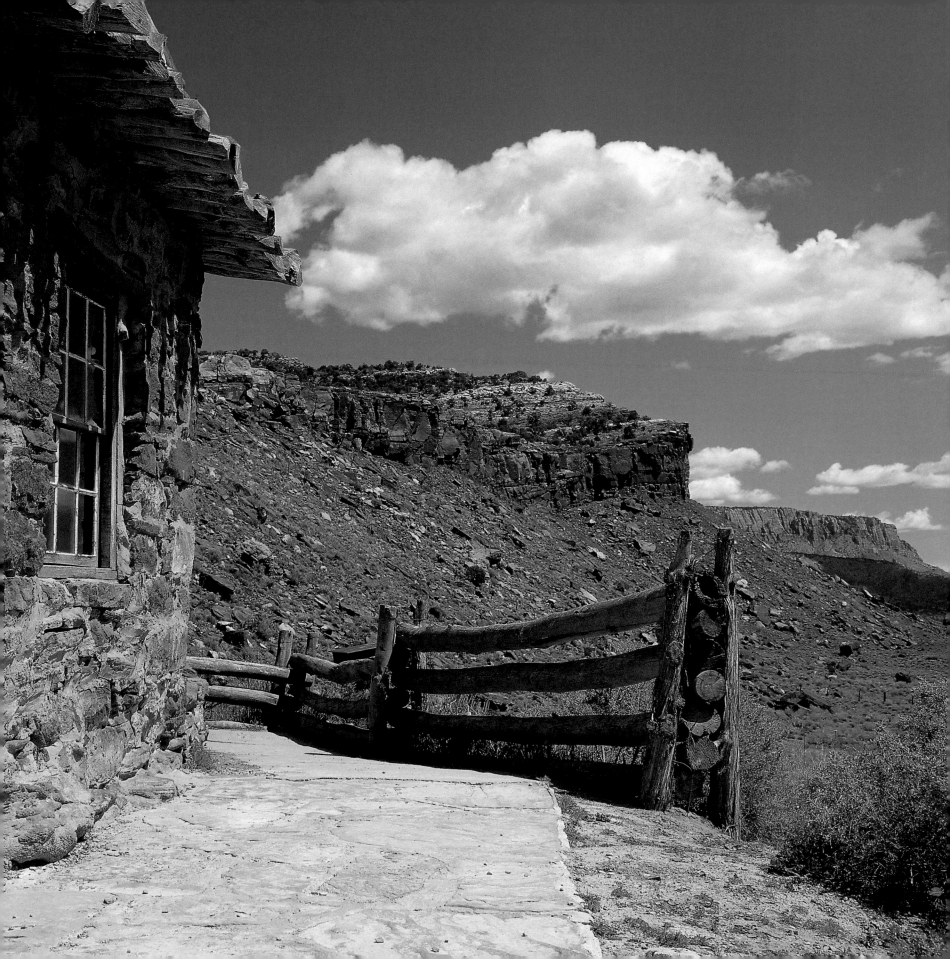

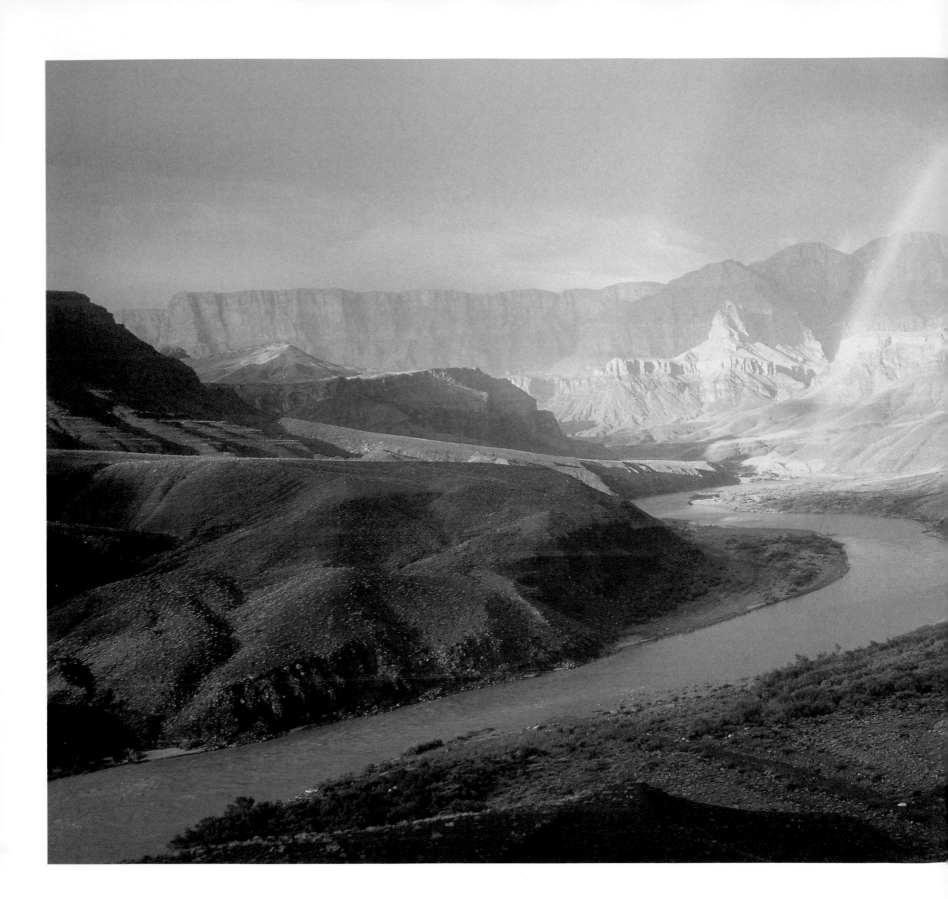

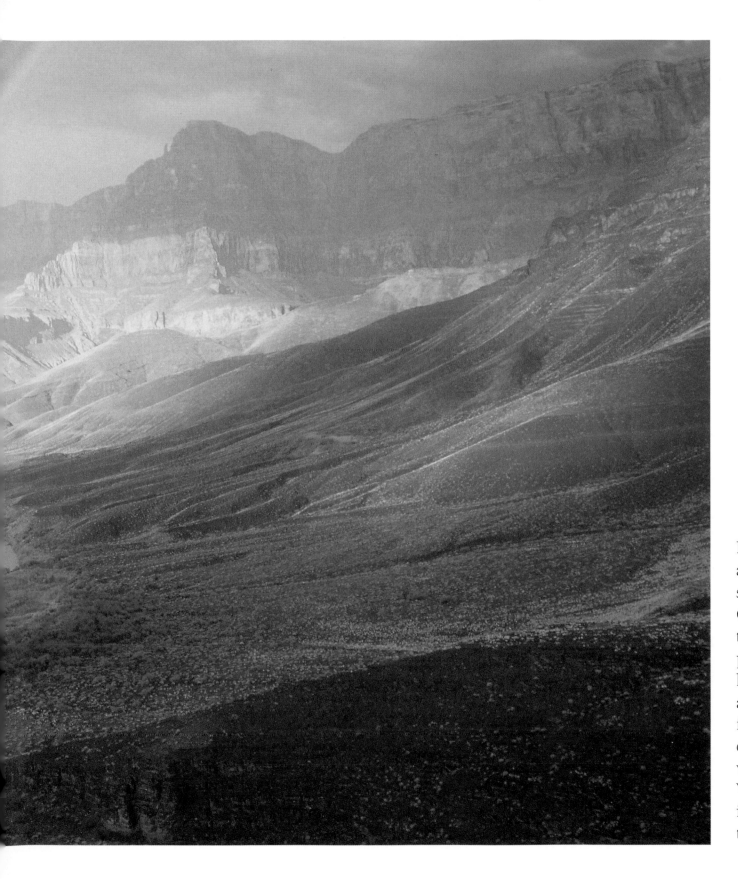

More than 2,700 archeological sites surround the Grand Canyon, revealing the lives of native peoples who lived here between 6000 and 2000 B.C. The first Europeans to explore the canyon were led by Francisco Vásquez de Coronado in 1540, in search of treasure for Spain.

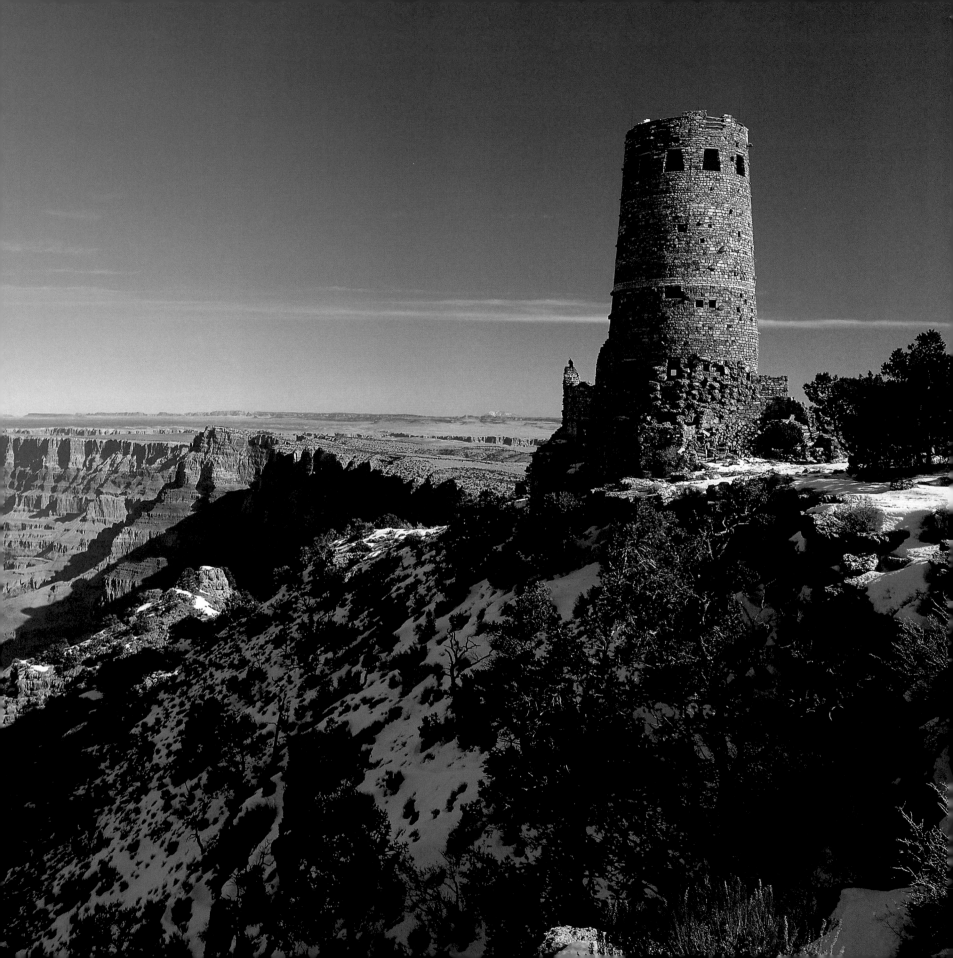

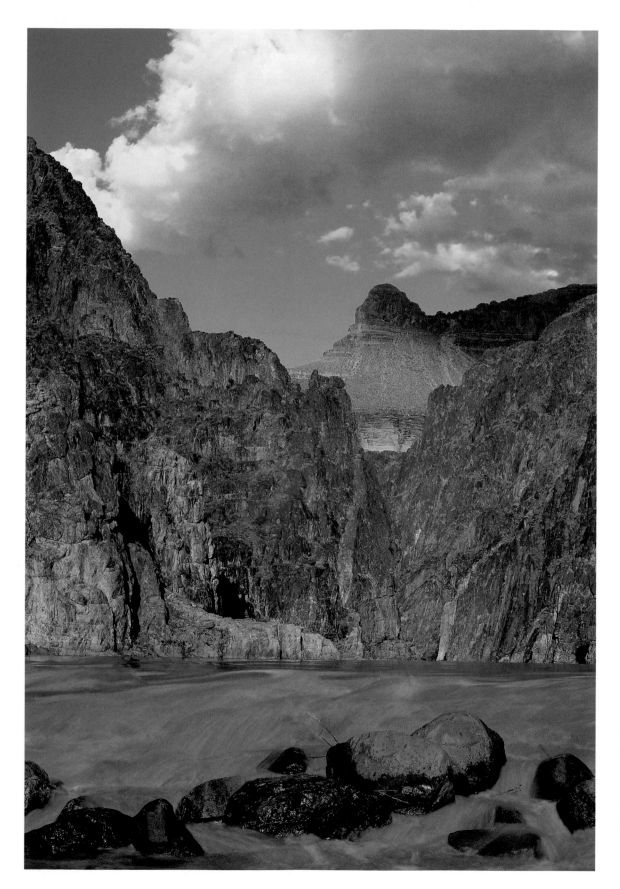

Granite Rapid is one of several rapids that add excitement to the rafting trip down the Grand Canyon. Visitors can choose short expeditions or an eight-day journey down the canyon's entire length.

OPPOSITE —
The Watchtower was designed by Mary Colter and built in 1932 by the Fred Harvey Company. The top of the Watchtower offers a 360-degree view of the canyon and the surrounding areas.

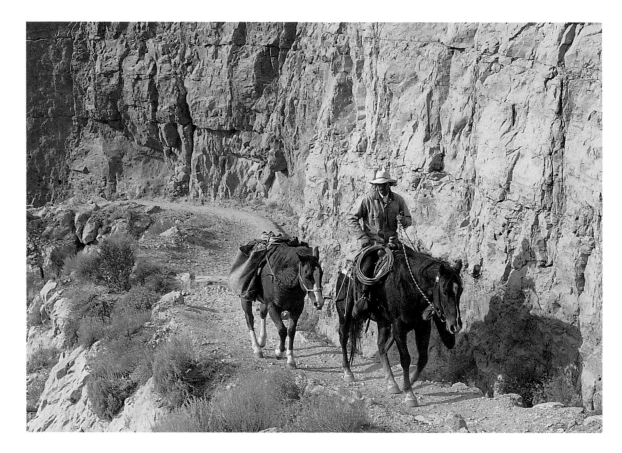

Visitors can view the canyon by helicopter, horseback, mule, or on foot. Trails from each rim lead around and into the gorge.

For more than 5 million years, the Colorado River has slowly carved into the earth, revealing rock that is billions of years old.

14

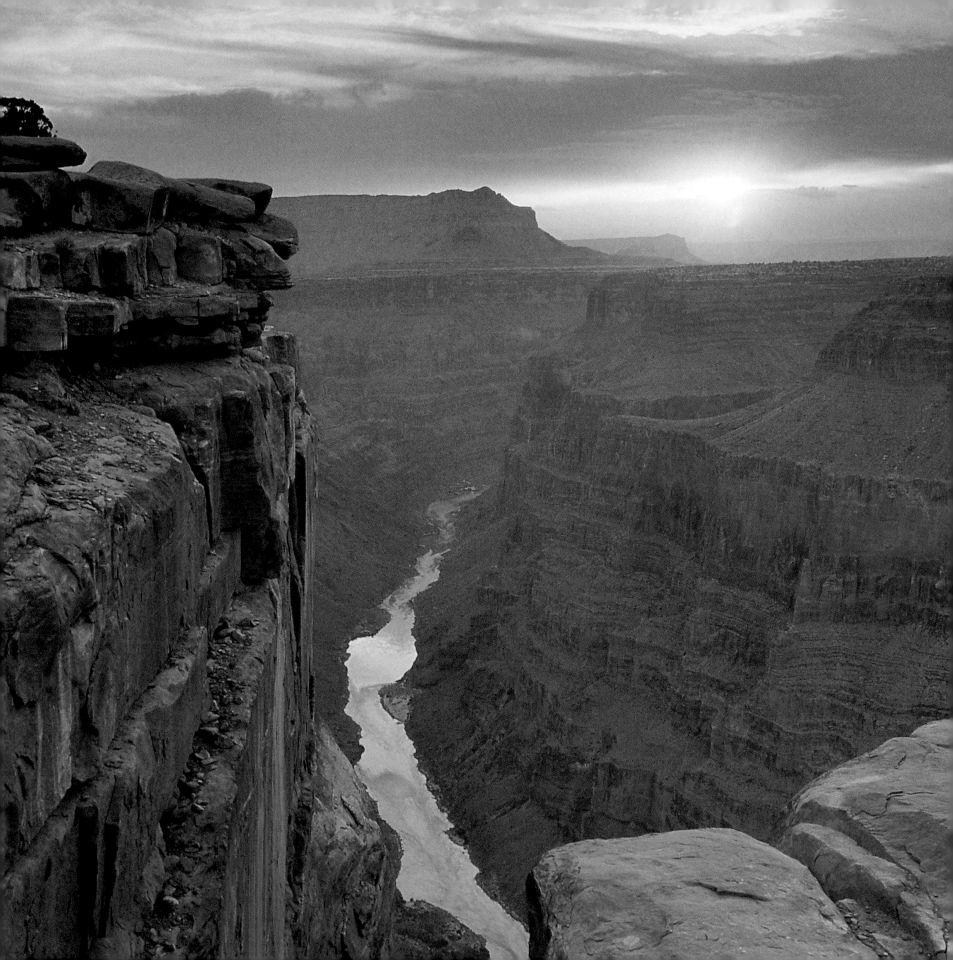

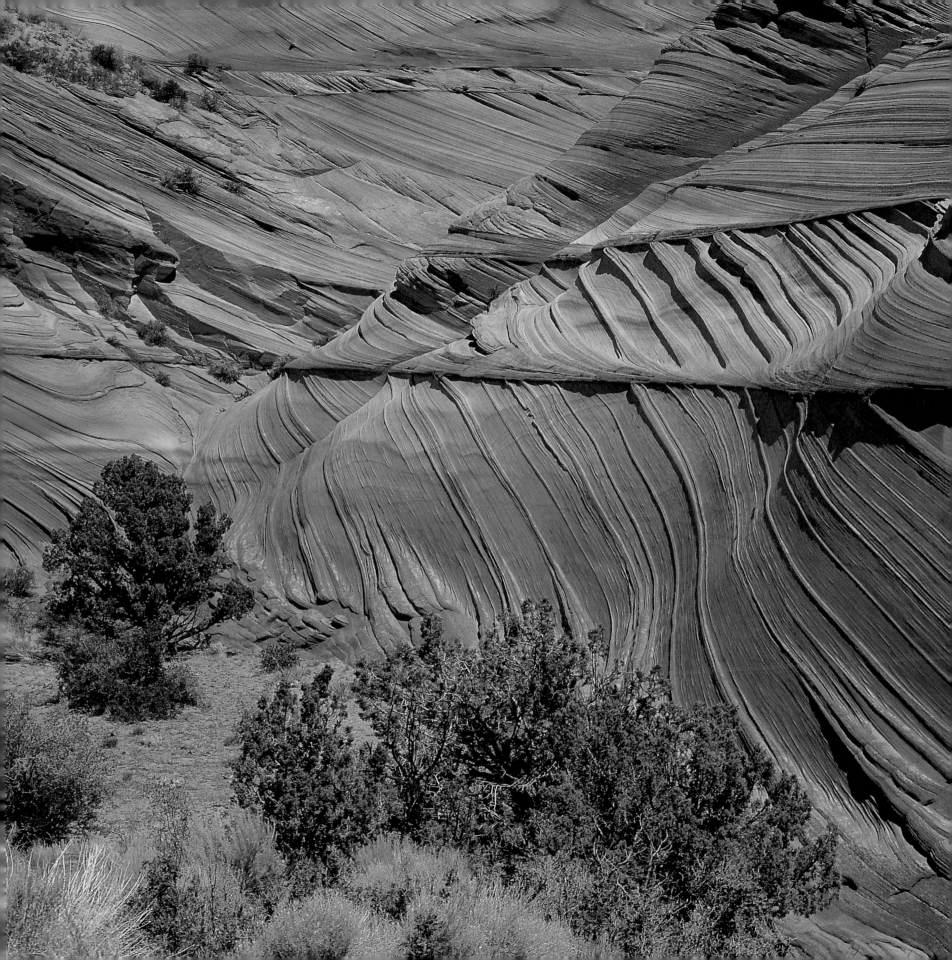

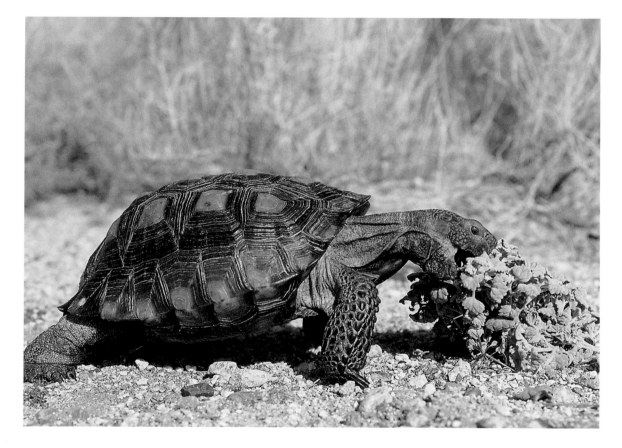

The slow-moving desert tortoise gets most of its water supply from moisture-rich plants. When water is available, a tortoise can drink almost half its body weight.

The dry expanse of the Paria Plateau is used mainly for ranching. Water for the livestock is hauled to the plateau by truck in this water-scarce environment.

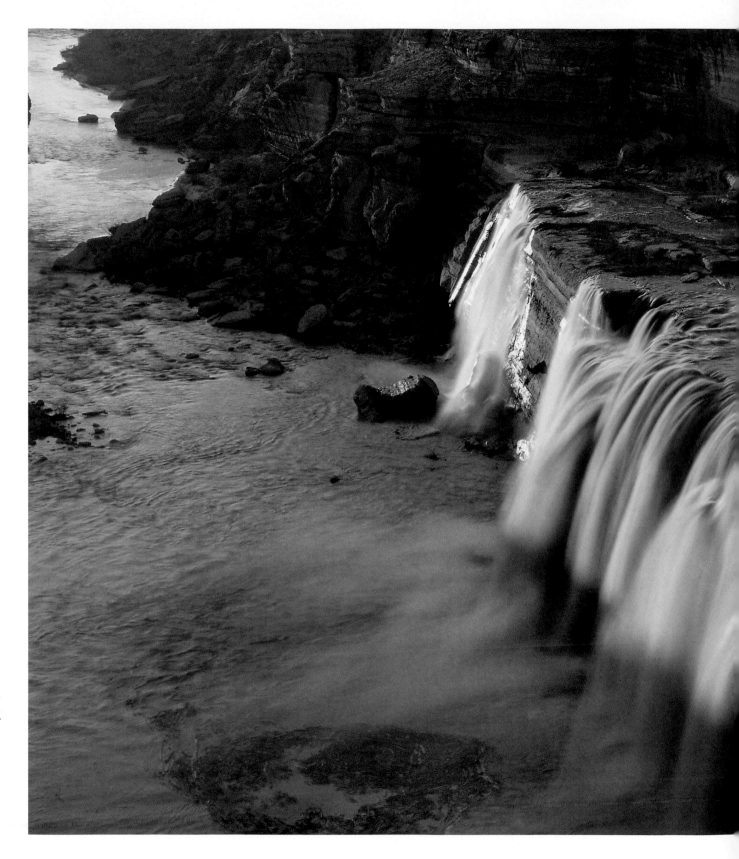

Swollen by the spring
runoff, Grand Falls
on the Little Colorado
River plunges 185 feet
into the canyon below.
By late spring, the
meltwater has gone
and only the sheer
cliff face remains
through the summer.

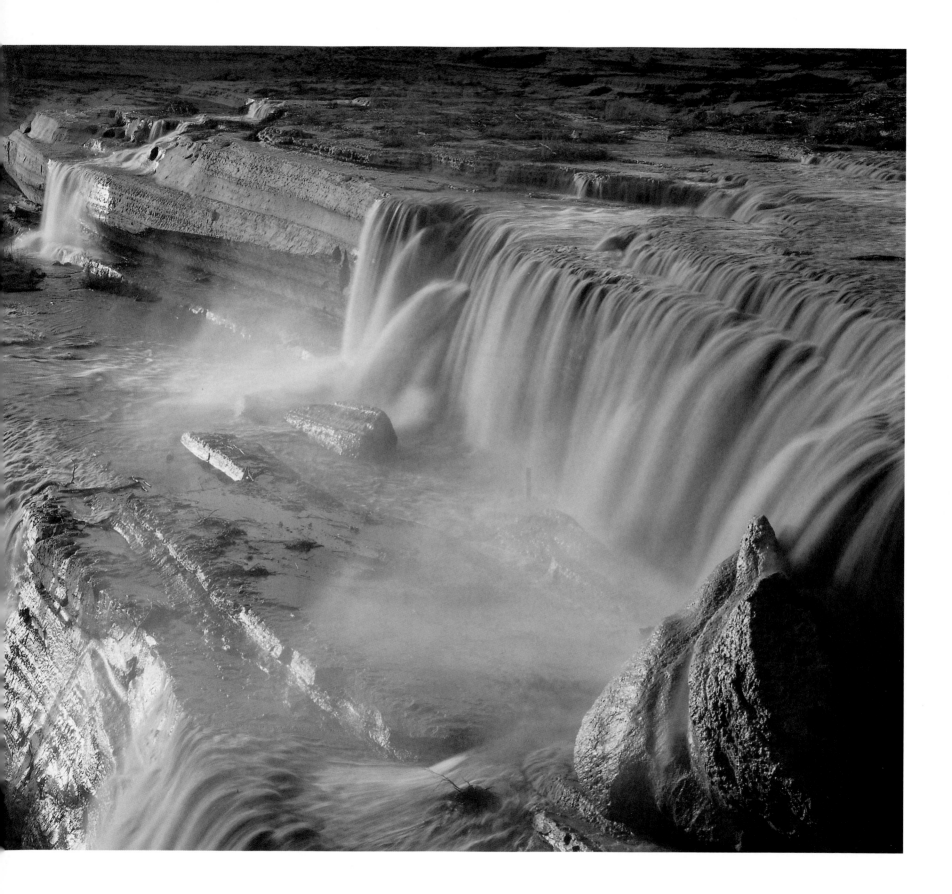

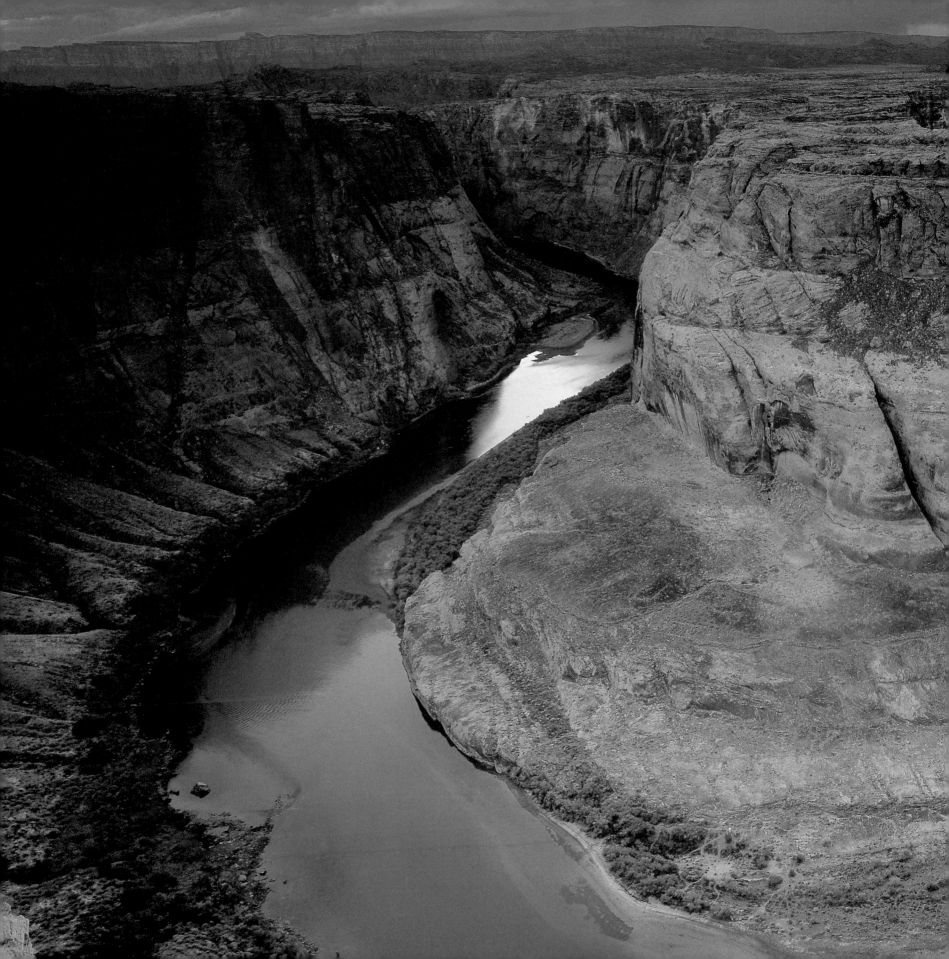

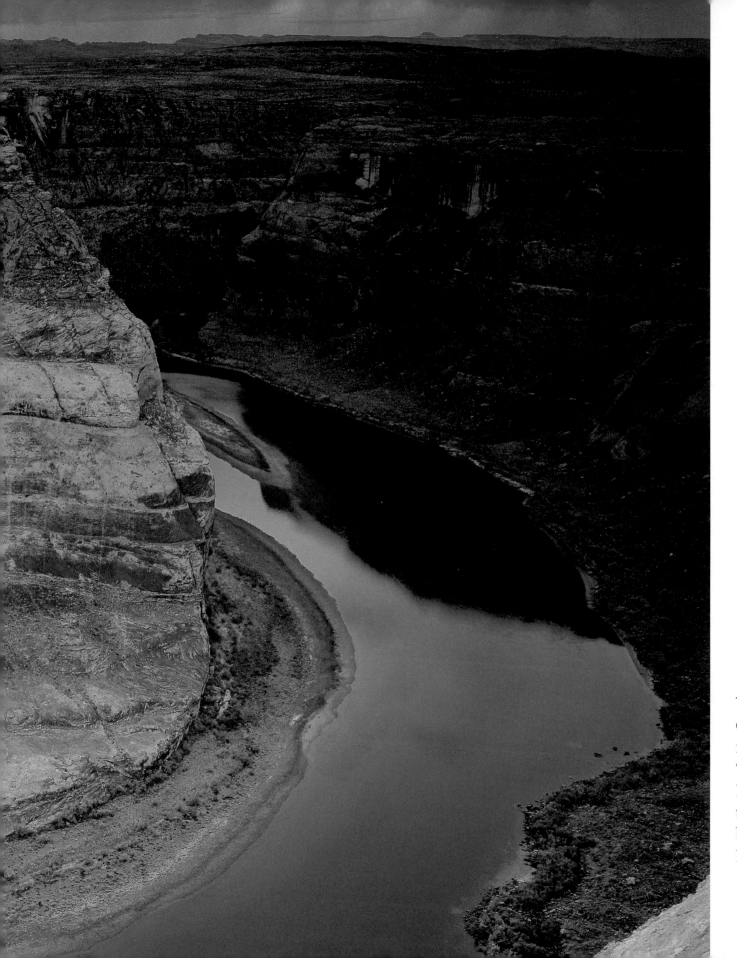

The name of the
Colorado River comes
from Rio Colorado—
"red river" in Spanish.
It was named in
the 18th century
by missionary Frey
Eusebio Kino.

21

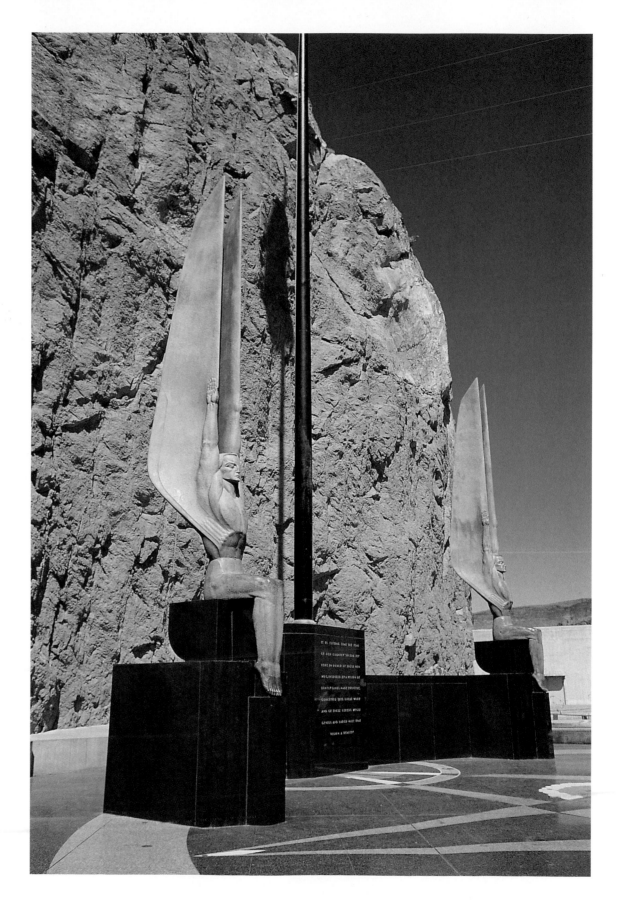

The Hoover Dam, built in 1935, was the first to tame the Colorado River. About 5,000 people worked on the construction of the dam, which is 726 feet high.

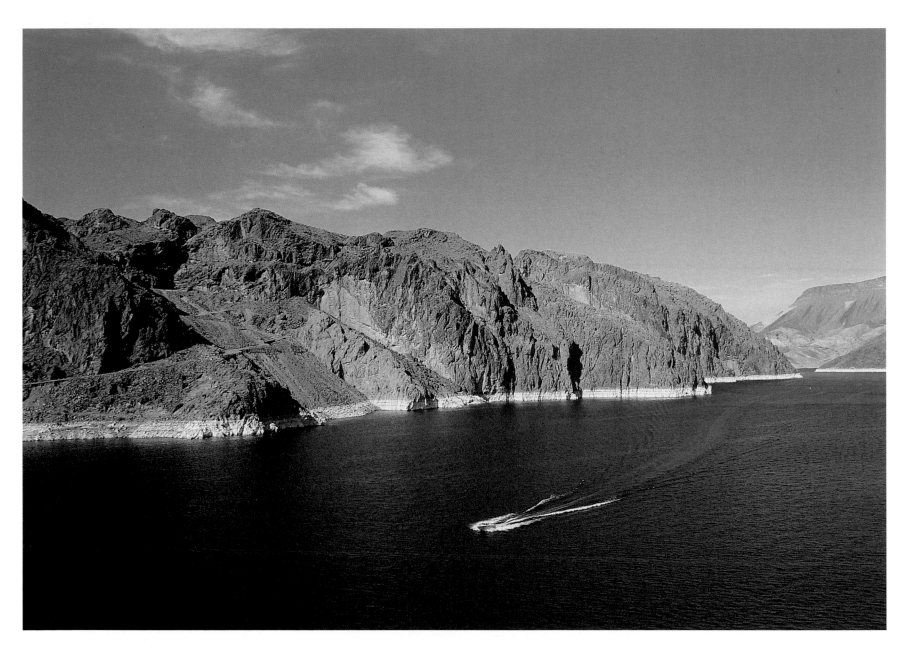

More than 130 miles long and twice the size of Rhode Island,
Lake Mead is the largest artificial lake in America. The area offers
a wide array of recreational opportunities, including sailing and fishing.

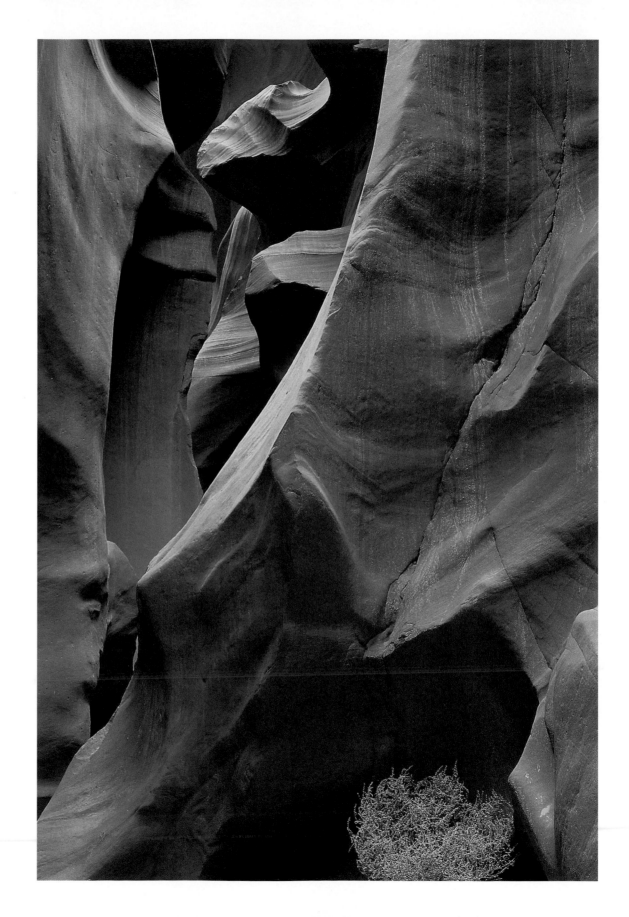

A crack in the sandstone allowed rushing flood water to carve Antelope Canyon, one of Arizona's best-known slot canyons. The light filters down from the narrow crack above, creating eerie orange and yellow hues on the canyon walls.

Originally a railroad town and a commercial center for surrounding mines, Kingman continues to support an important mining industry. The city is well known for its supply of turquoise.

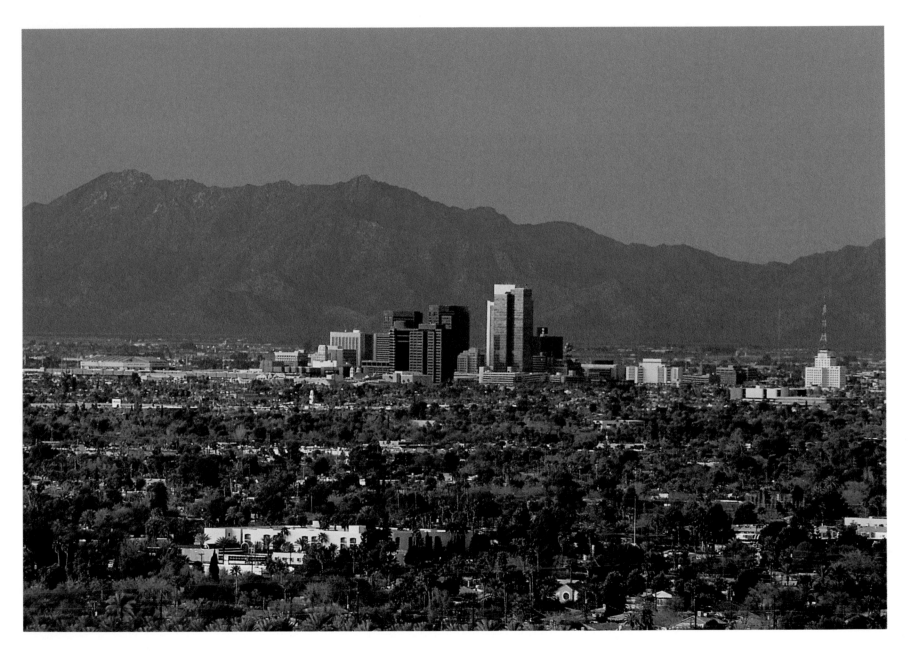

Phoenix is one of the largest centers in the U.S. Despite its growing
population, the city is surrounded by an array of untouched peaks and valleys,
including South Mountain Park, the largest municipal park in the world.

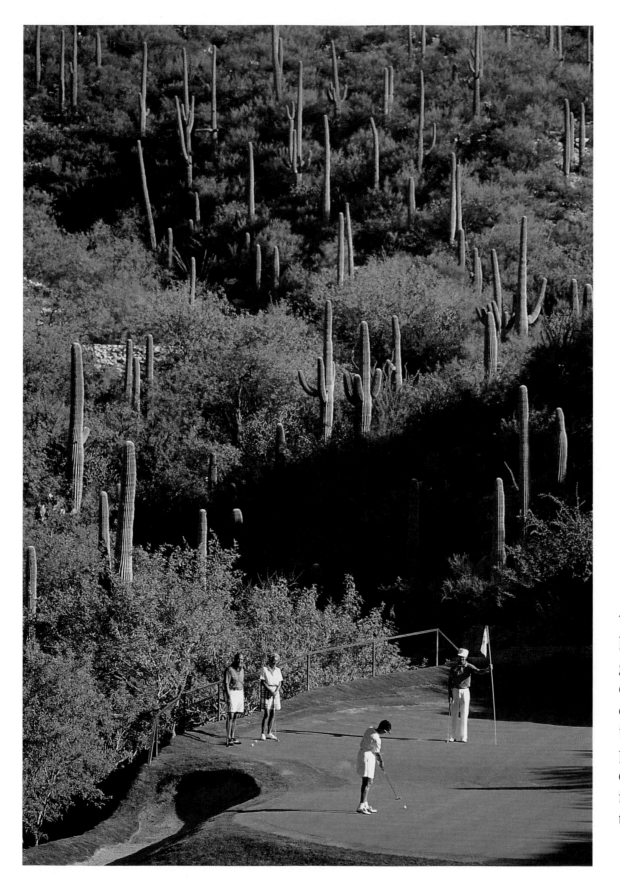

The contrast of the lush greenery of the golf course with arid desert hills, limestone canyons, and rock formations is made possible through extensive irrigation in the dry lands of the Southwest.

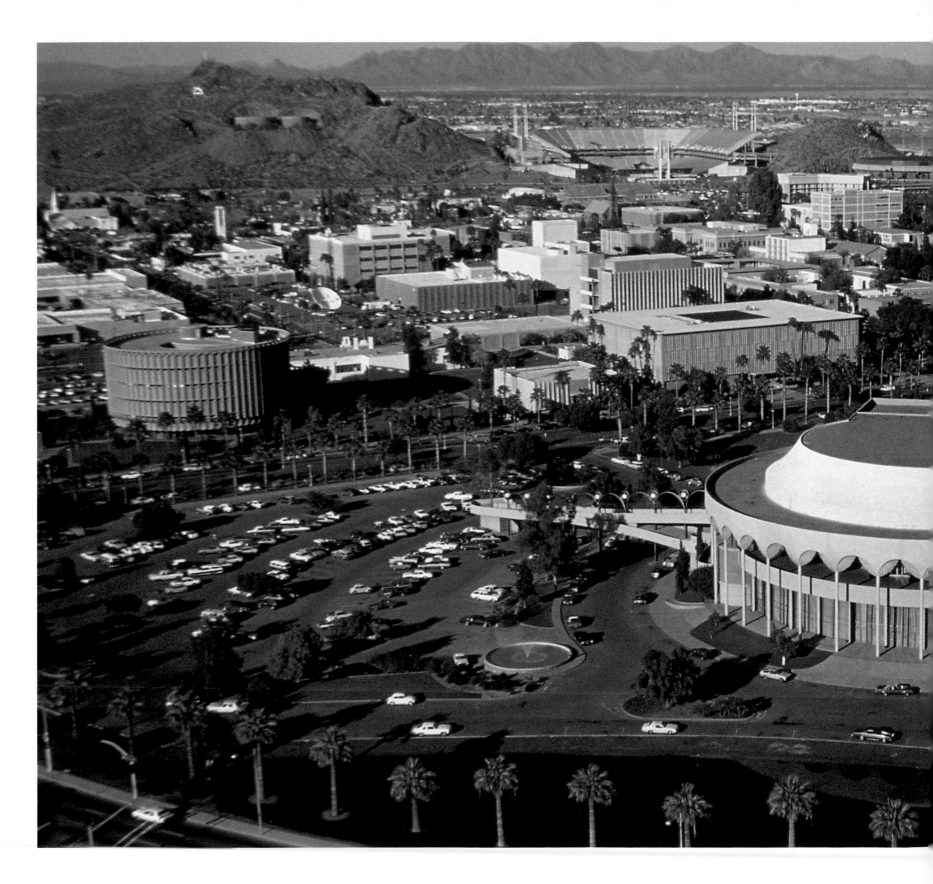

Arizona State University's main campus in Tempe has about 41,000 students enrolled in about 150 graduate and 86 undergraduate programs.

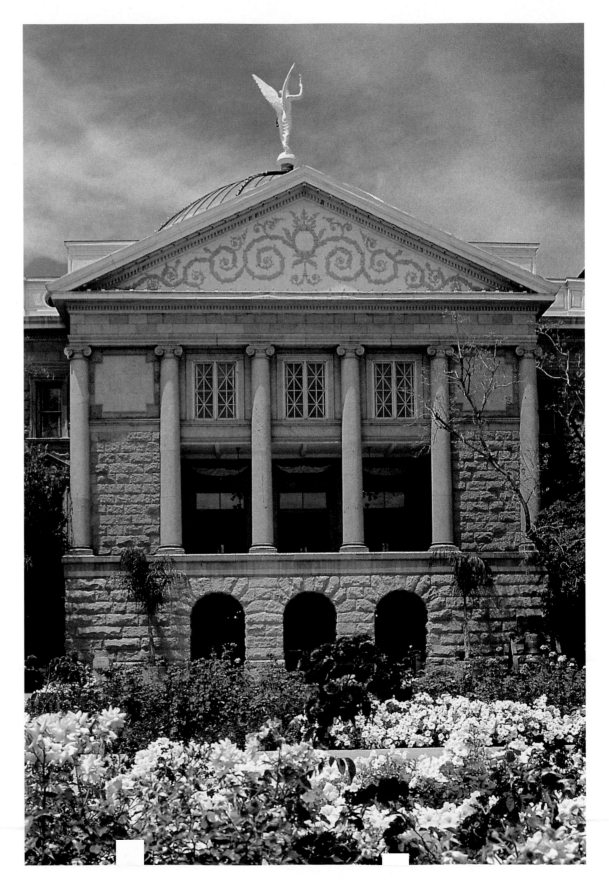

The first capital building was erected in Phoenix in 1900, when the city was the capital of the territory. It became the state capital in 1912, and the present building was constructed in the 1970s.

Boutiques and cafés make Scottsdale's shopping district a favorite with visitors. Art enthusiasts can tour architect Frank Lloyd Wright's studio, drop by the Scottsdale Center for the Arts, or visit one of more than 200 local galleries.

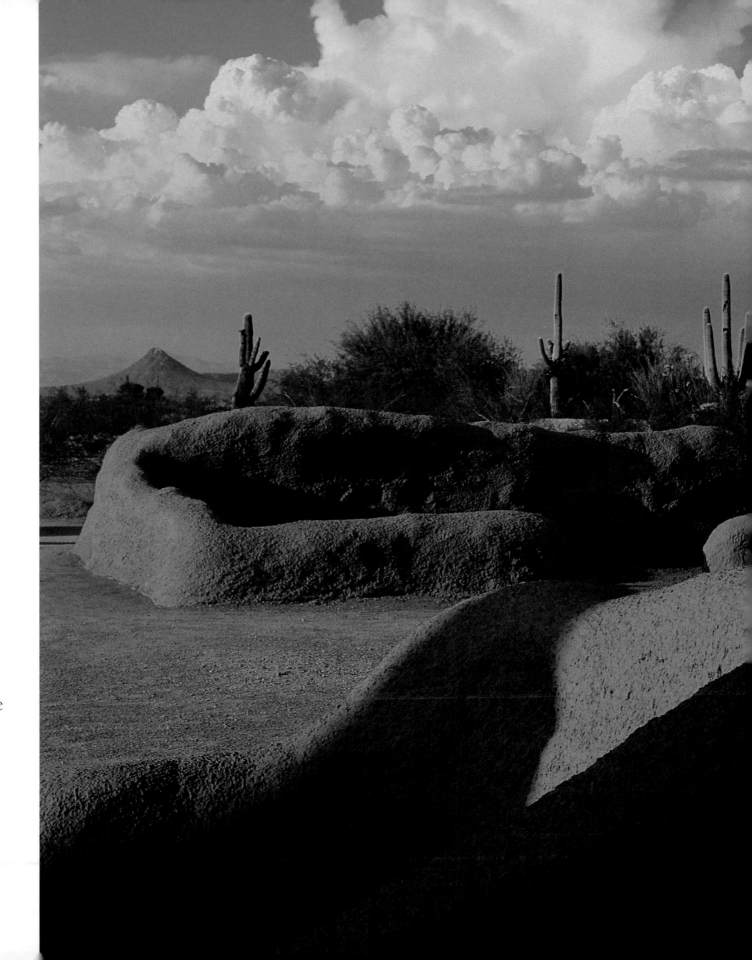

Built in the 1300s
by the Hohokam—
whose name means
"those who have
gone"—Casa Grande
was constructed of
more than 600 giant
beams with walls
more than four feet
thick. The structure
was abandoned in
the 15th century.

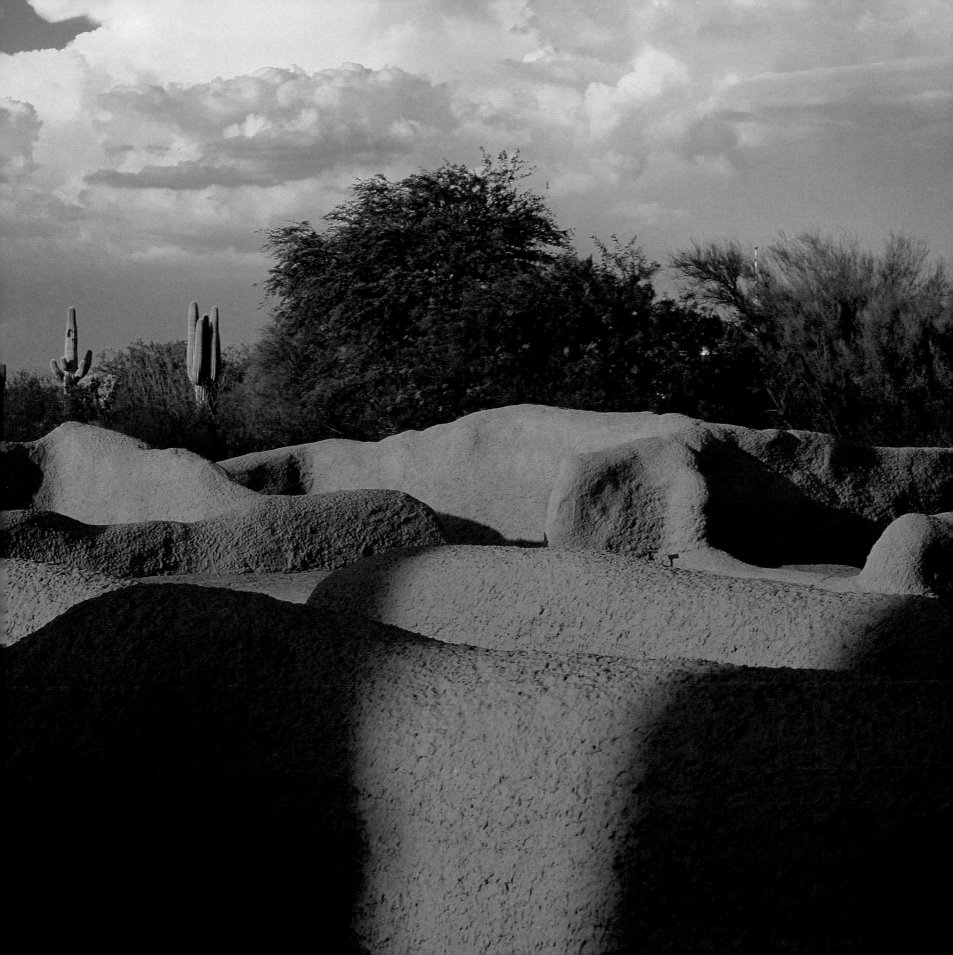

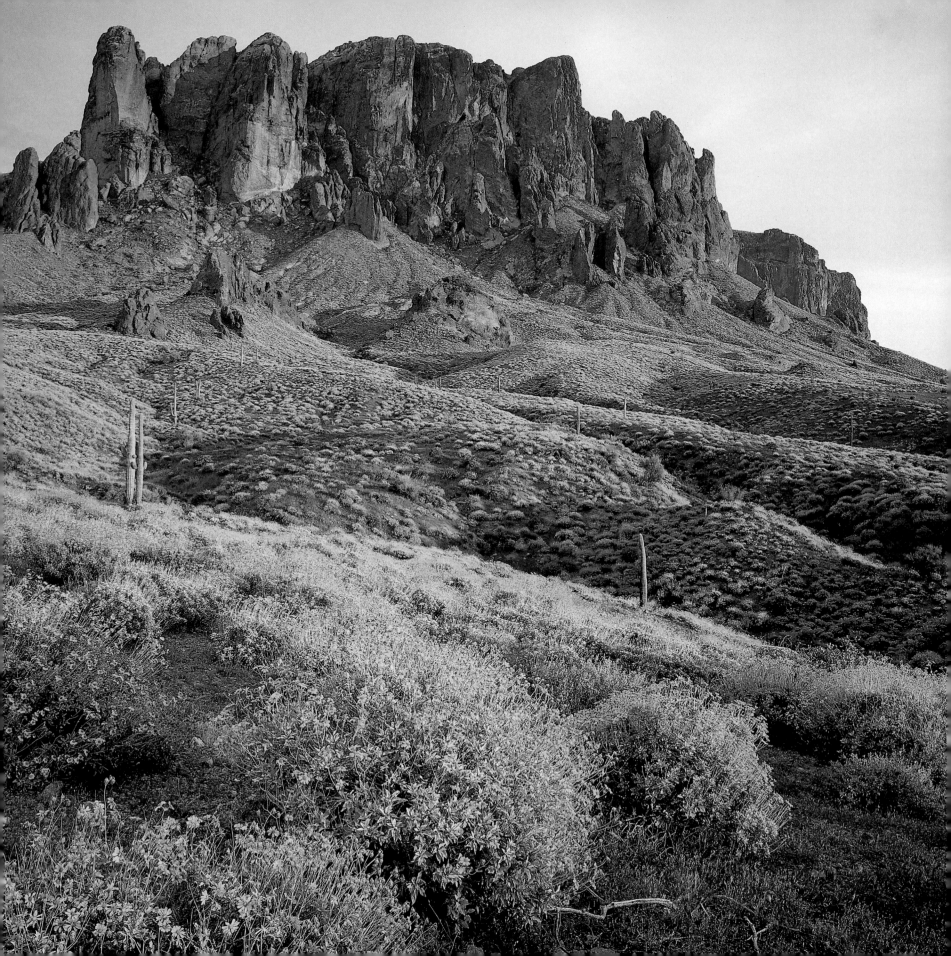

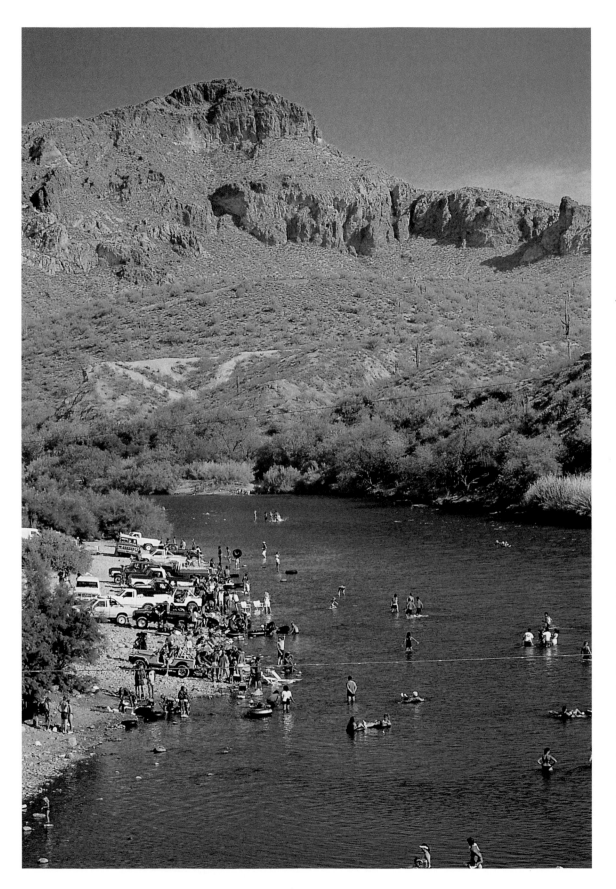

Just outside of Phoenix, the banks of the Salt River are a popular swimming and picnicking destination.

OPPOSITE —
The Superstition Mountains near Phoenix are the site of the legendary Lost Dutchman Mine. The story of the mine was started by a German immigrant, who claimed to know of a rich gold find in the mountains. Others have searched for the mine since the prospector's death in 1891.

The brilliant blooms of staghorn cholla contrast with the dry earth. Spines aren't the only defence this cactus has against predators. A thin layer of toxin in its stems makes the plant poisonous.

OPPOSITE —
The chain-fruit cholla is the largest member of the cholla family. Unlike the closely related prickly-pears, chollas have round stems. The chain-fruit is named for its connected strings of fruit.

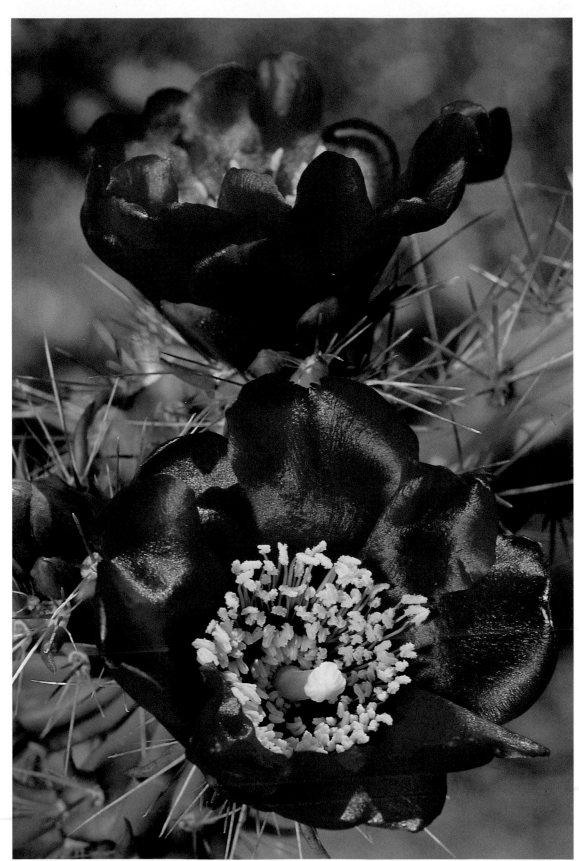

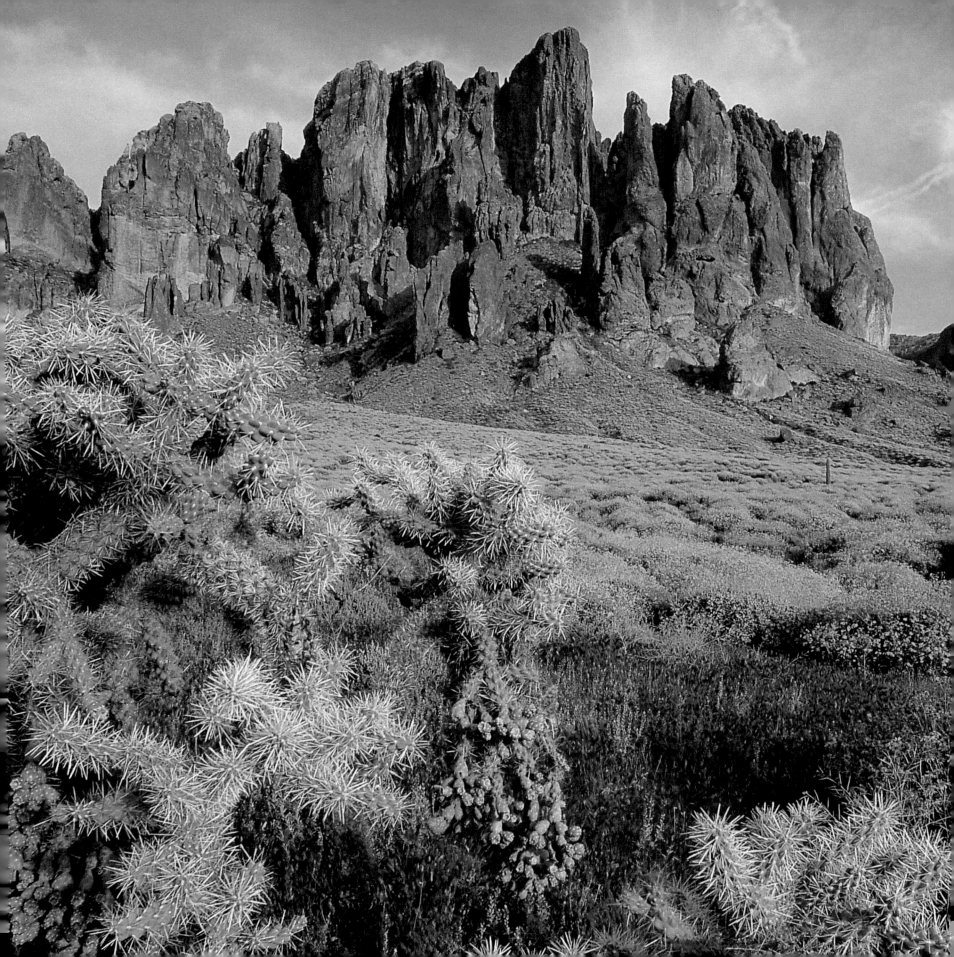

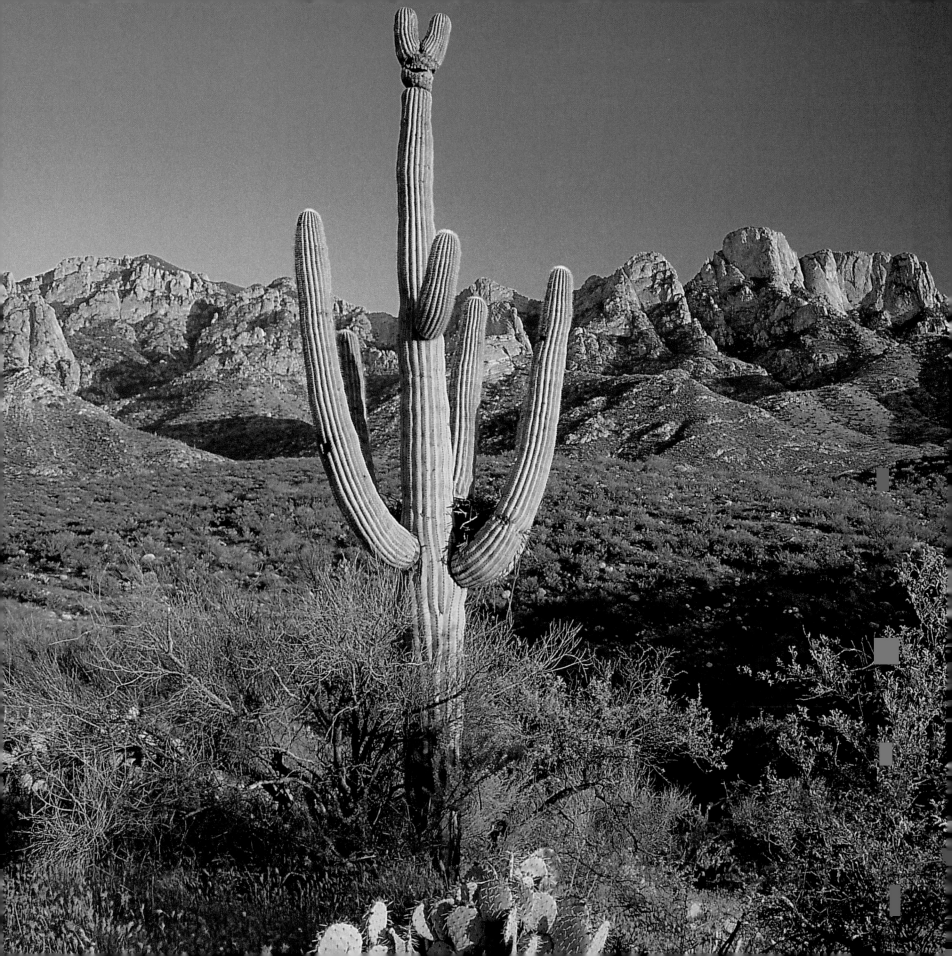

Saguaro National Monument, named after Arizona's largest native cactus, protects two sections of the Sonoran desert. The bloom of the saguaro cactus is the state's official flower.

Trails wind through more than 83,000 acres protected by Saguaro National Monument, allowing hikers or horseback riders the chance to discover the park's array of desert flora and fauna.

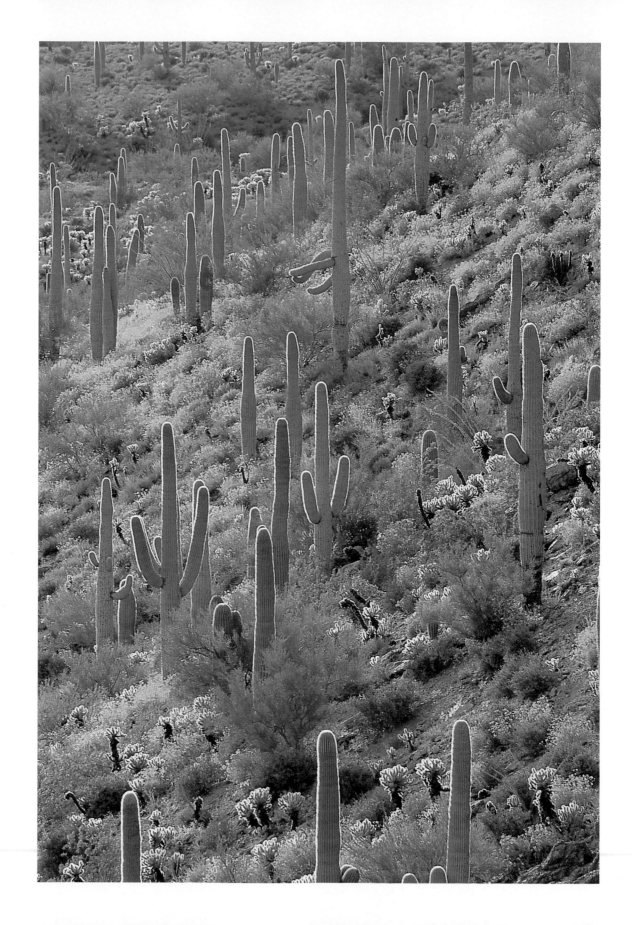

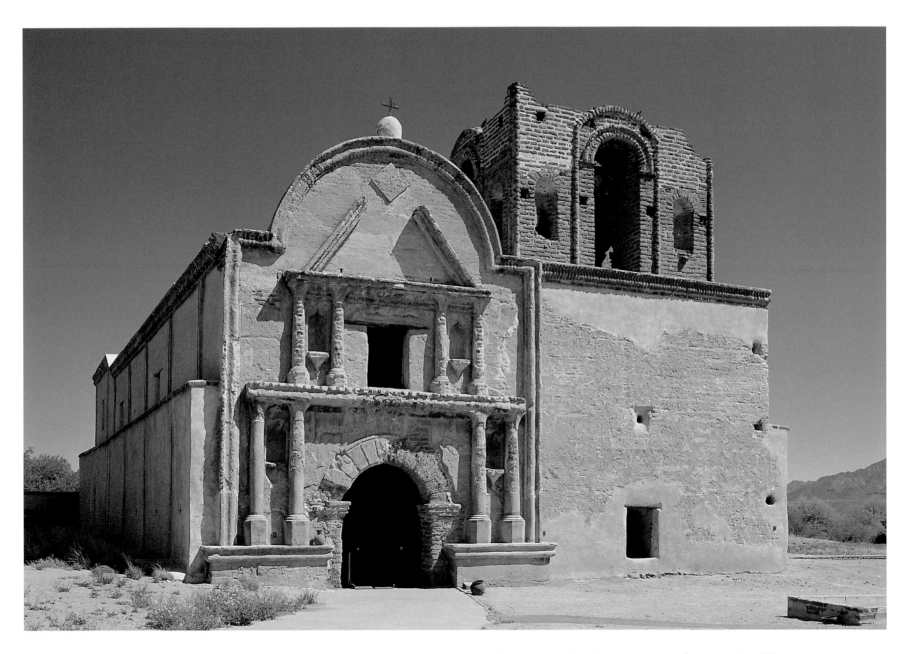

Tumacacori National Historic Park preserves the ruins of three missions built in the early 1800s. The missions were opposed by local native peoples and by the Mexican government, and were abandoned only a few decades after they were built.

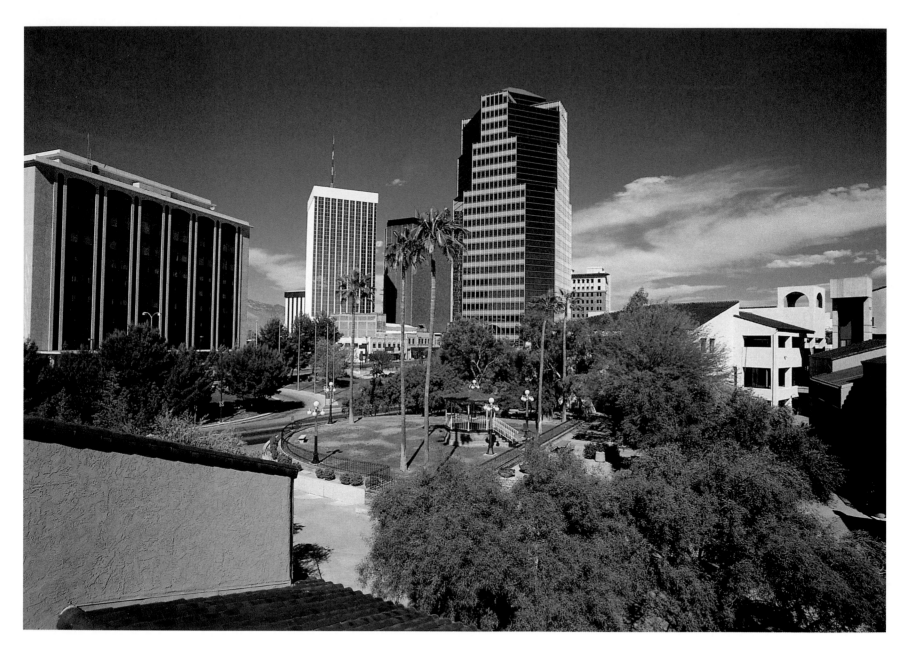

Known for its easygoing atmosphere, Tucson and its surrounding area
offers a wide array of recreation options, from golf at the world-class
Ventana Canyon Golf and Racquet Club to boating on Patagonia Lake.

Tucson was once
part of Mexico—
a fact reflected in
the traditional pueblo
architecture found
throughout the city.

43

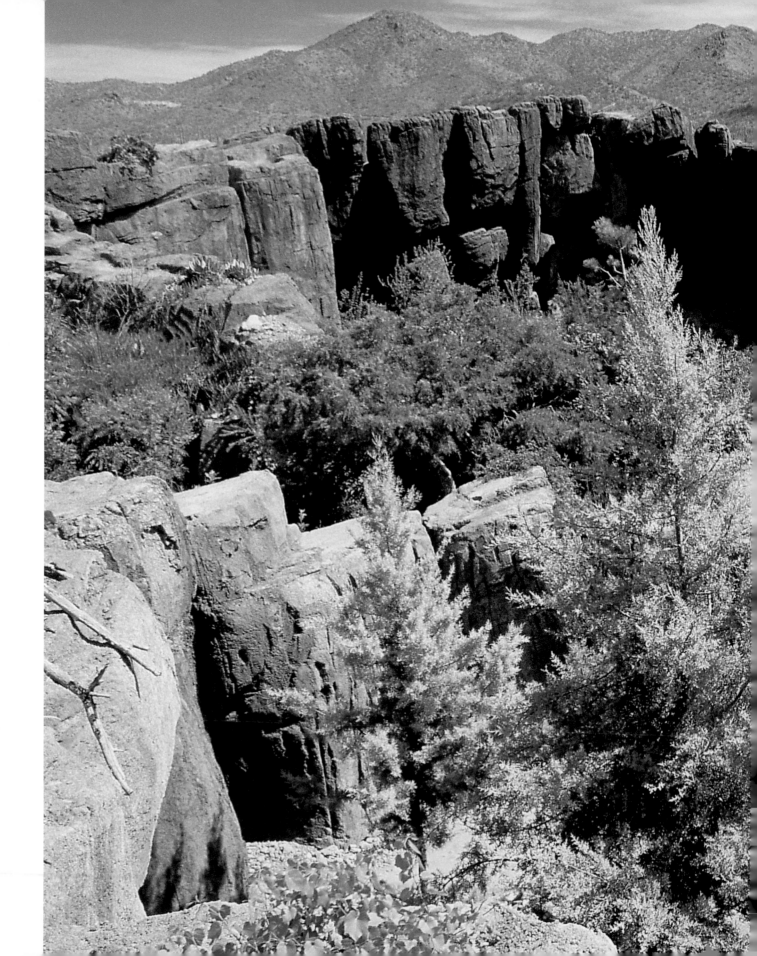

The Arizona-Sonora
Desert Museum in
Tucson contains
thousands of plant
and animal species
in a spectacular
natural habitat.

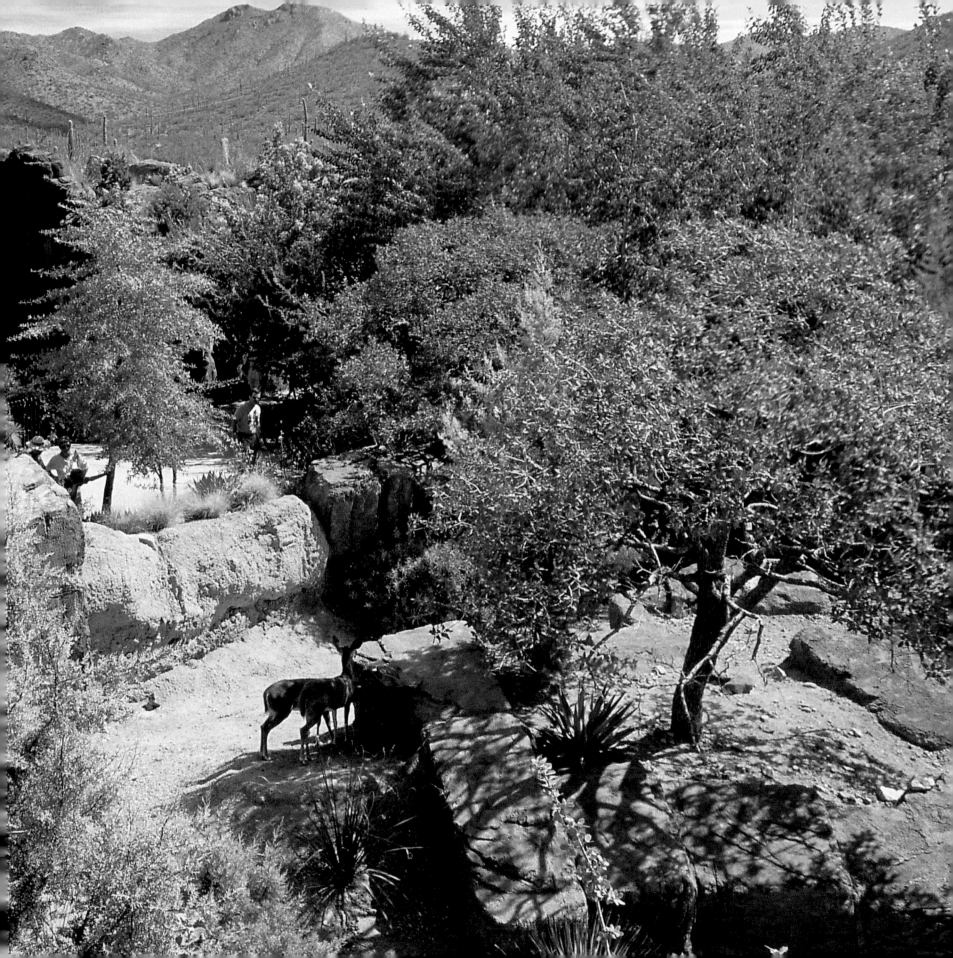

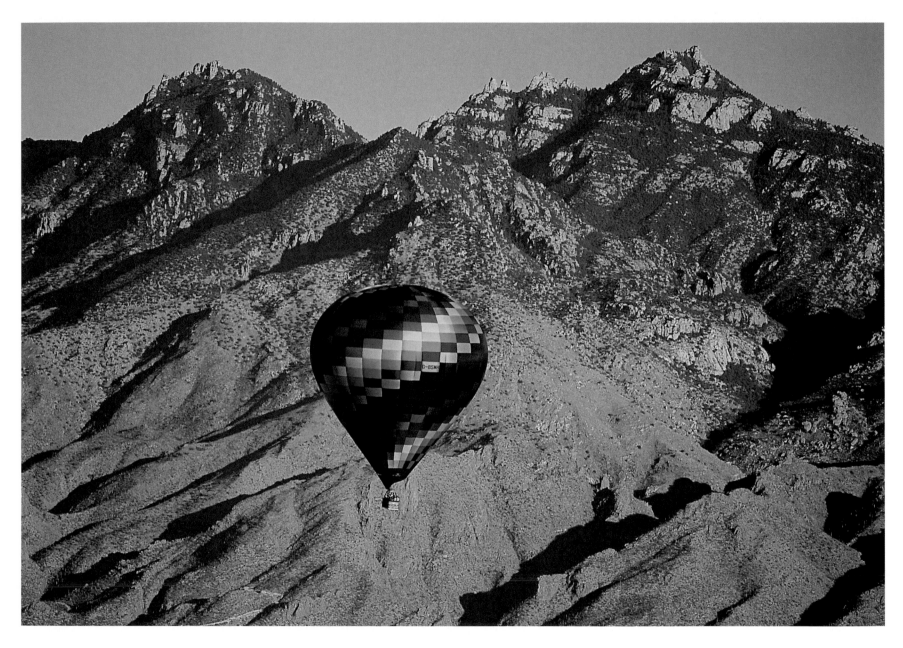

An early morning or sunset balloon ride over the Sonoran desert allows
visitors a panoramic view of the surrounding landscape and a chance
to glimpse the desert wildlife.

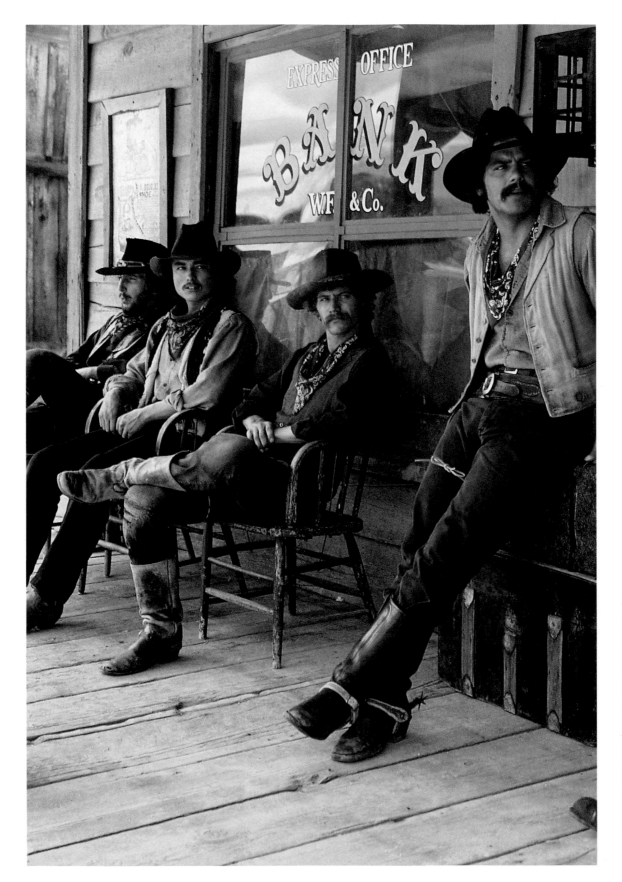

A replica of the early city, Old Tucson was built as a Hollywood stage for Wild West movies, beginning with the filming of *Arizona* in 1939. Now best known as a theme park, it is still occasionally used as a movie set.

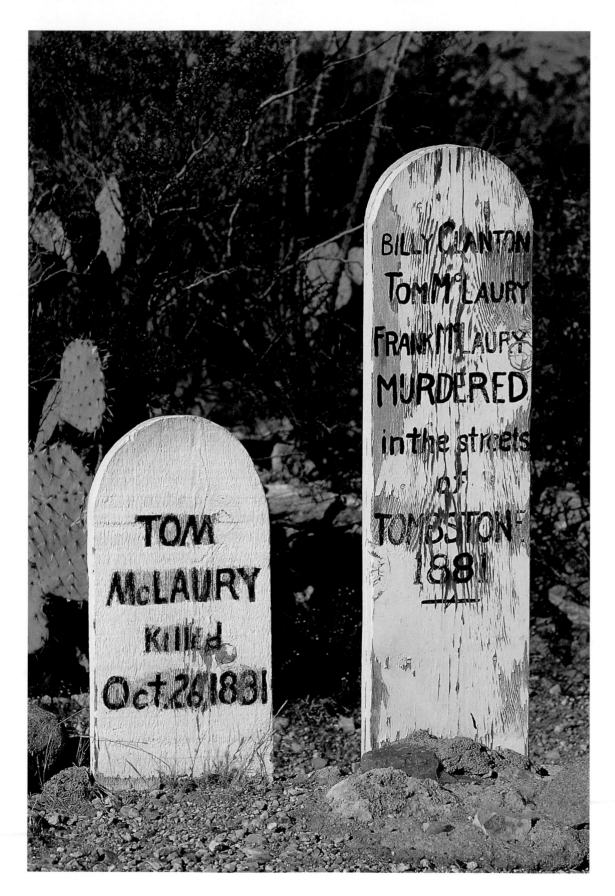

Visitors arrive at Boothill Graveyard to tour the resting place of about 200 outlaws. The Old West town of Tombstone, known as "the town too tough to die," is the site of the infamous O.K. Corral shootout.

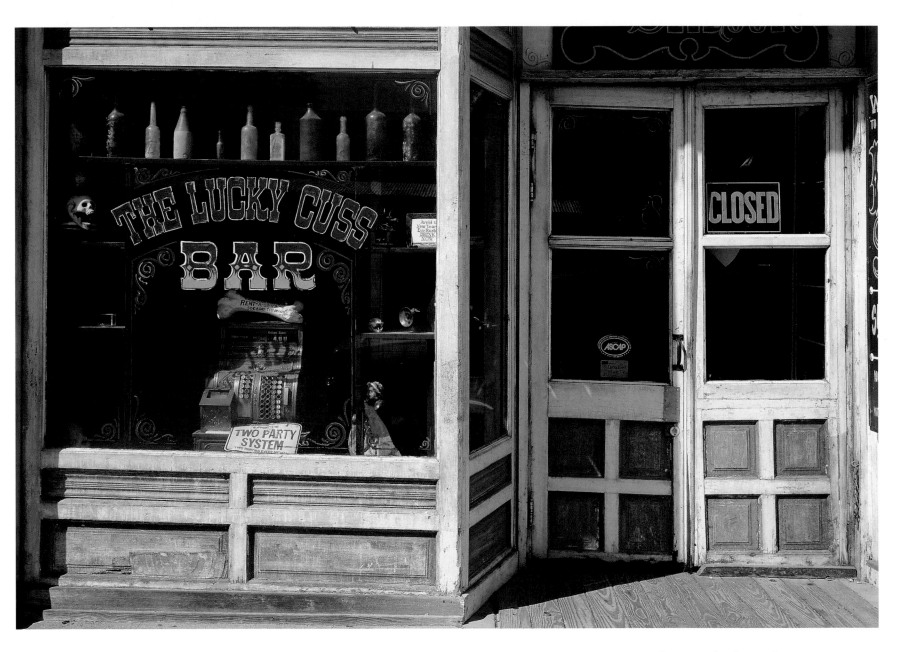

Home of the legendary Wyatt Earp, Tombstone boomed after silver was discovered in the 1870s. The population had dropped drastically by the early 1900s, but tourism has slowly brought the Wild West town back to life.

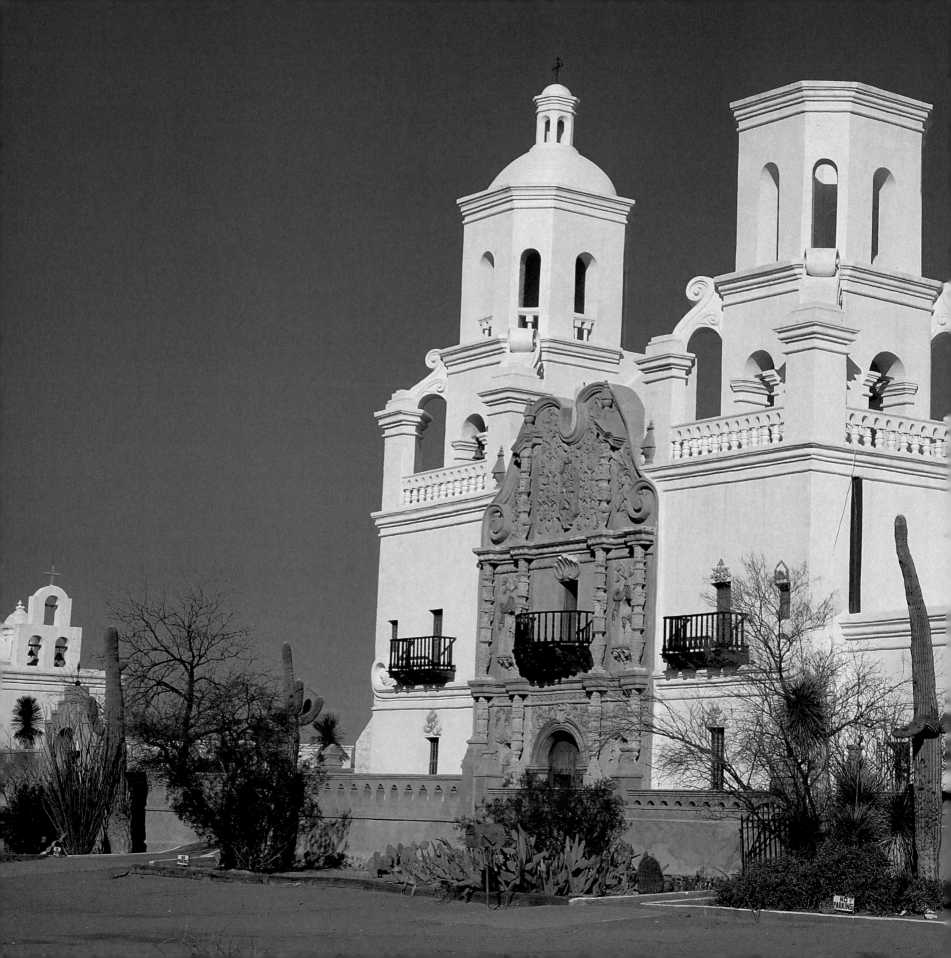

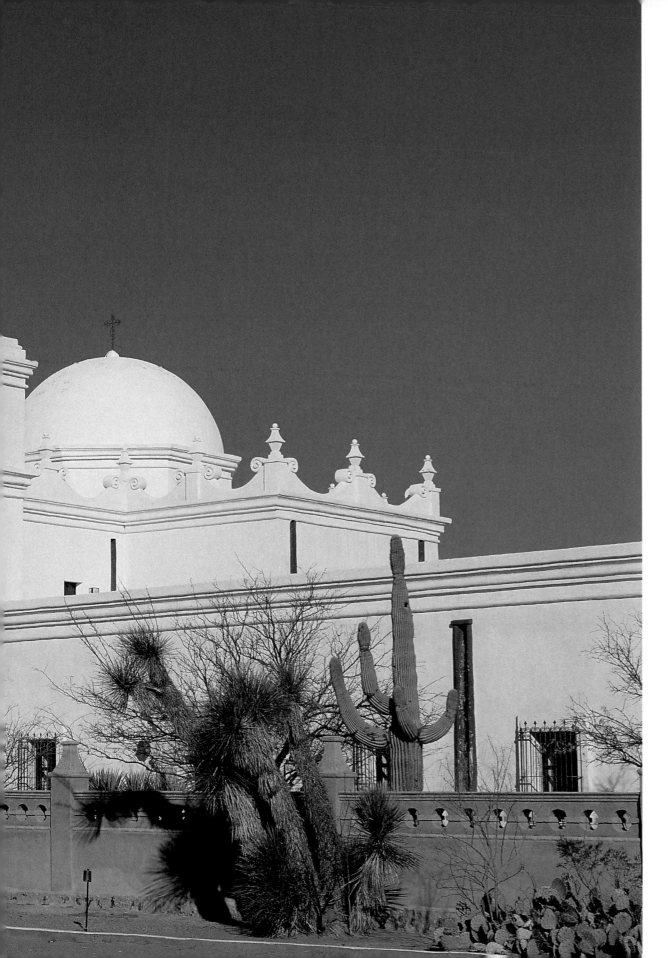

Father Eusebio Kino
began ministering
to the residents of
Bac in 1700. Later,
in the 18th century,
Franciscan missionar-
ies built the Spanish-
style church that still
stands in the San
Xavier Reservation
today.

With more than 20 tele-
scopes, Kitt Peak National
Observatory helped earn
Tucson the title of Astro-
nomy Capital of the World.
The telescope pictured here
is 18 stories high.

OPPOSITE —
Once a center for copper
mining, the idyllic town
of Bisbee has now been
declared a National Historic
District. Restored homes
and businesses are drawing
more and more visitors to
the Old West community.

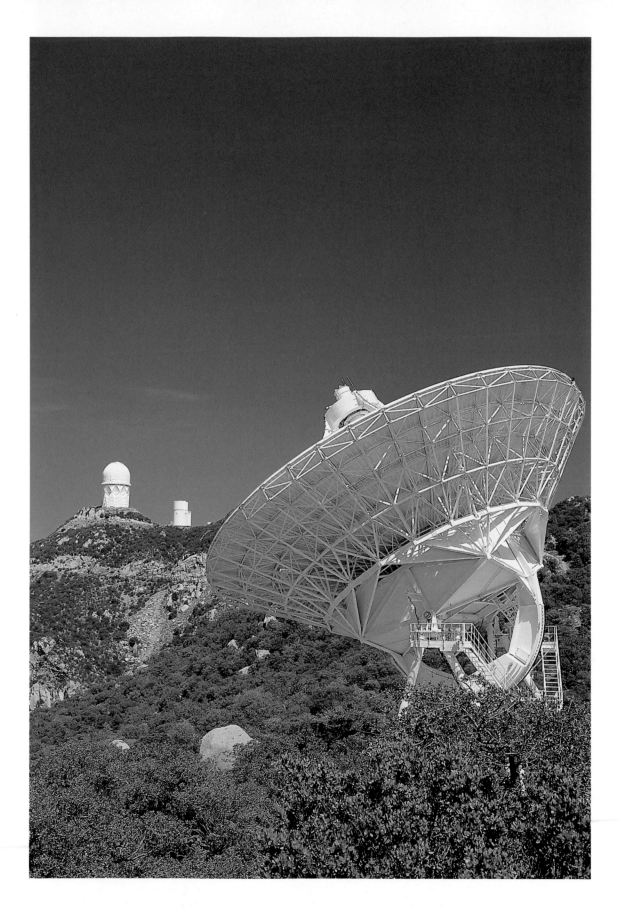

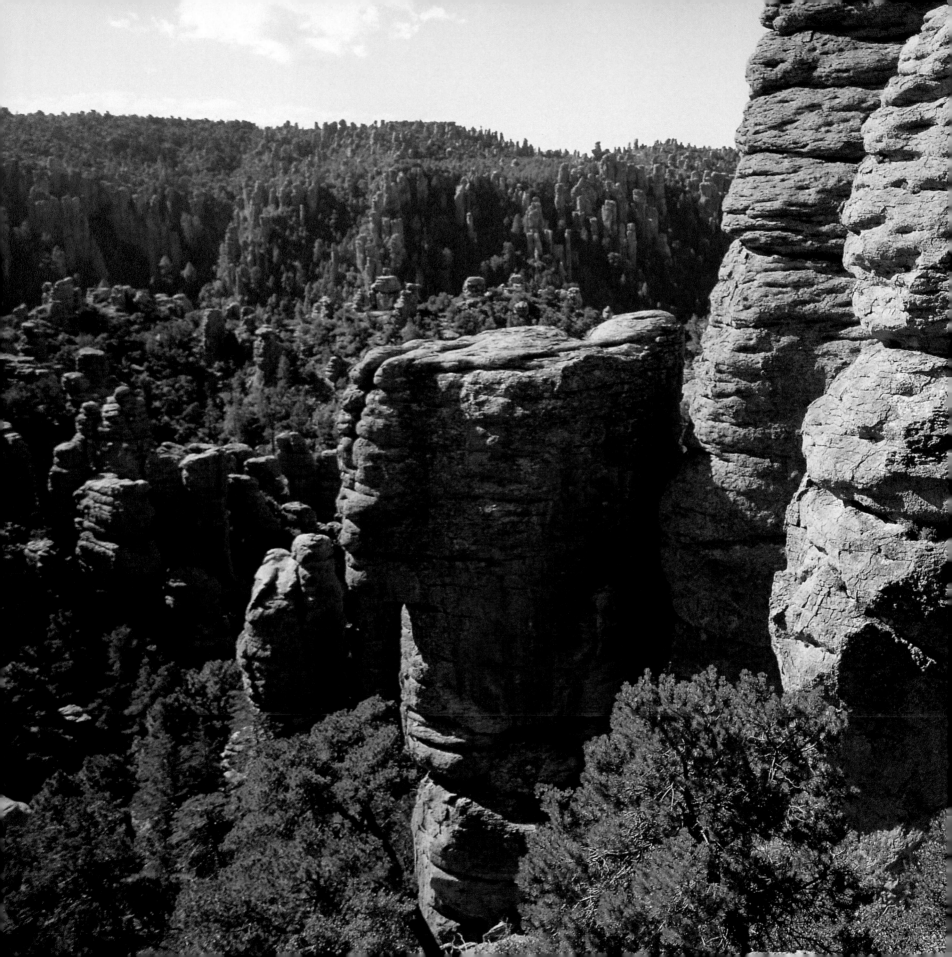

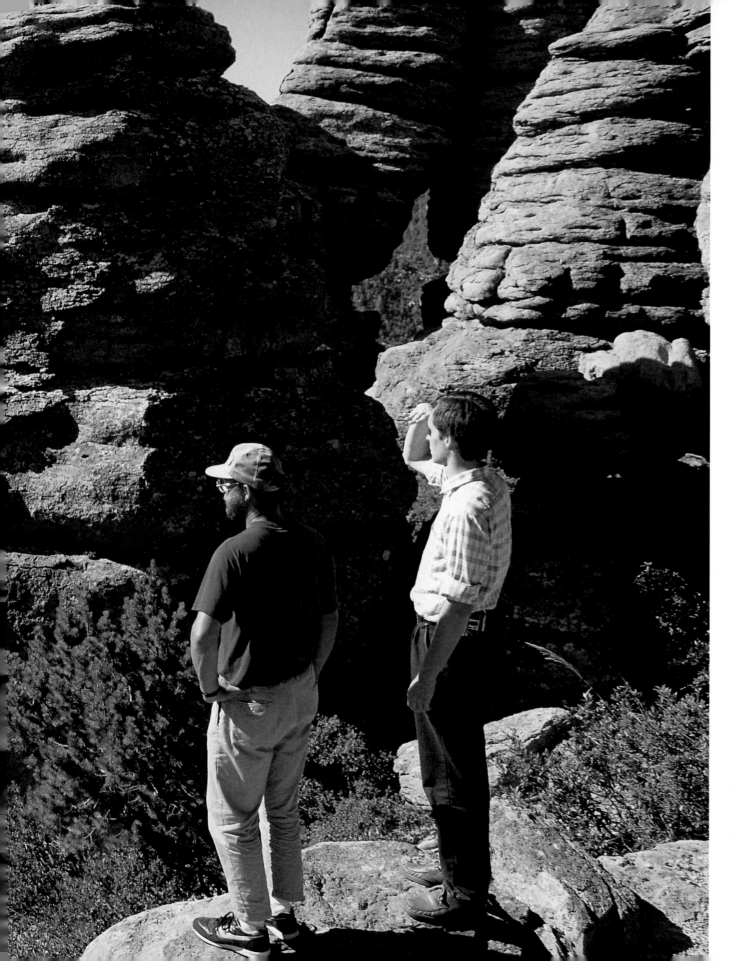

Formed when the softer volcanic earth around them eroded, hoodoos create an eerie atmosphere in the Chiricahua Mountains.

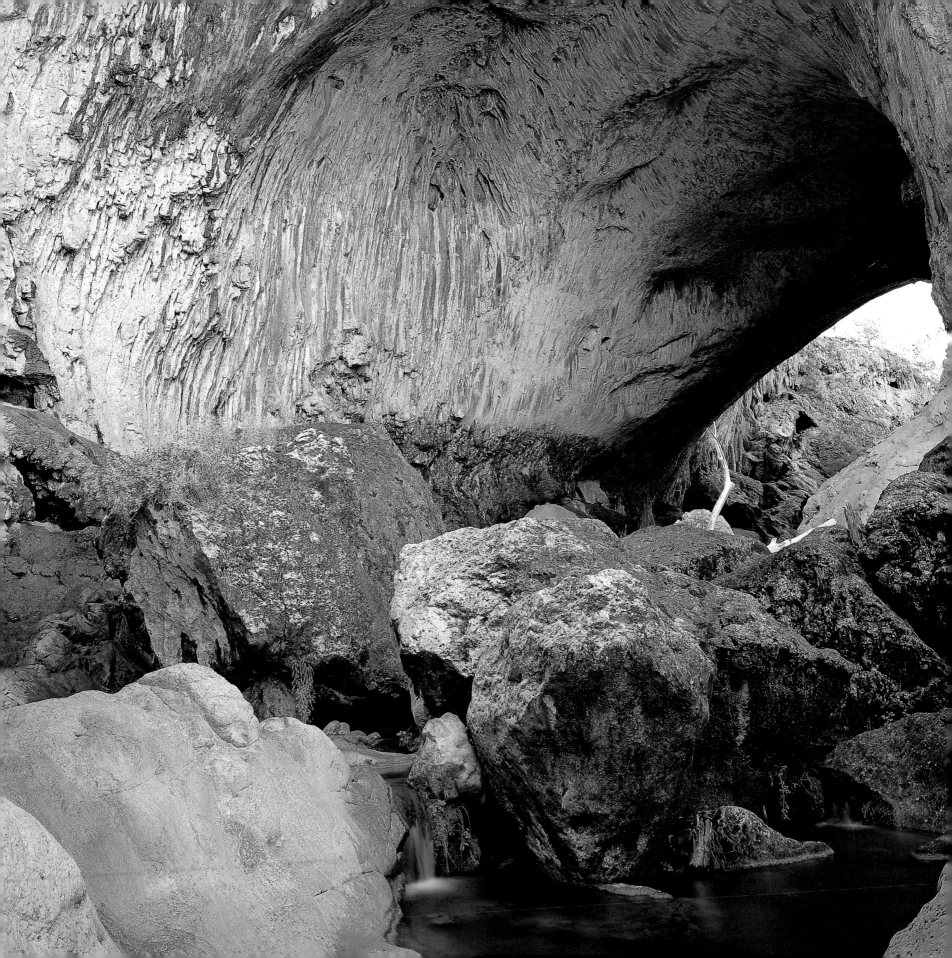

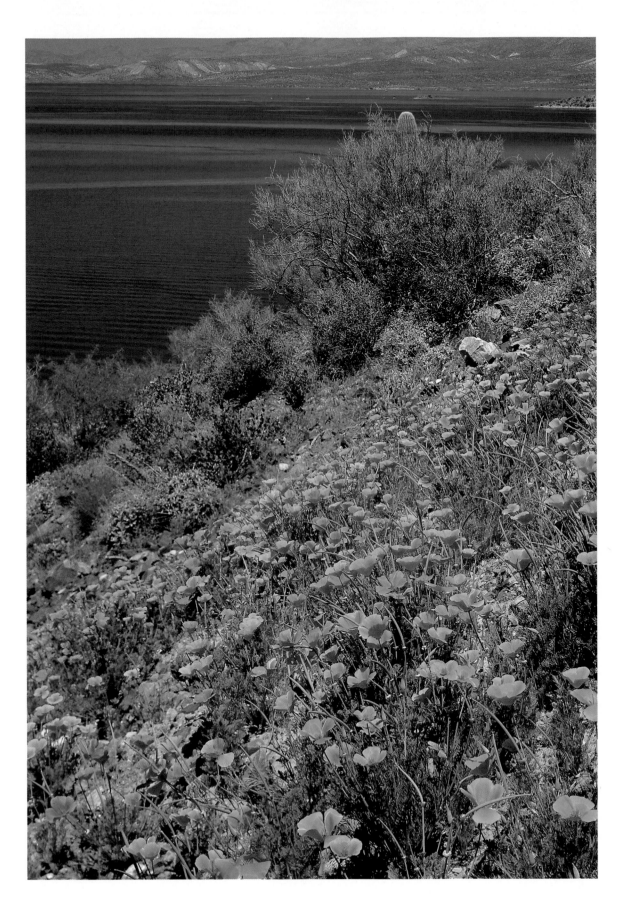

Roosevelt Lake was created with the construction of Theodore Roosevelt Dam—the country's first hydroelectric dam—in 1911. Along with nearby Apache and Saguaro lakes, Roosevelt is a popular recreation area, offering camping, fishing, hiking, and picnicking.

OPPOSITE —
The limestone arch of Tonto Natural Bridge is the largest in the world.

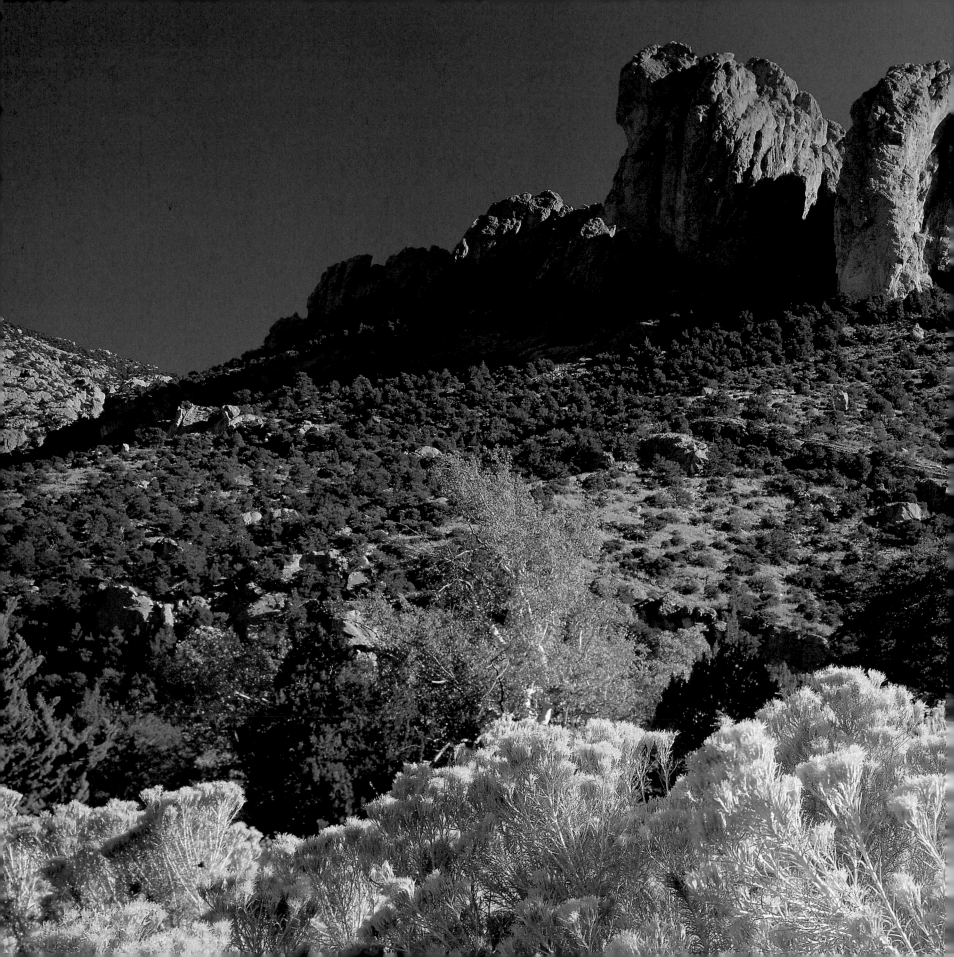

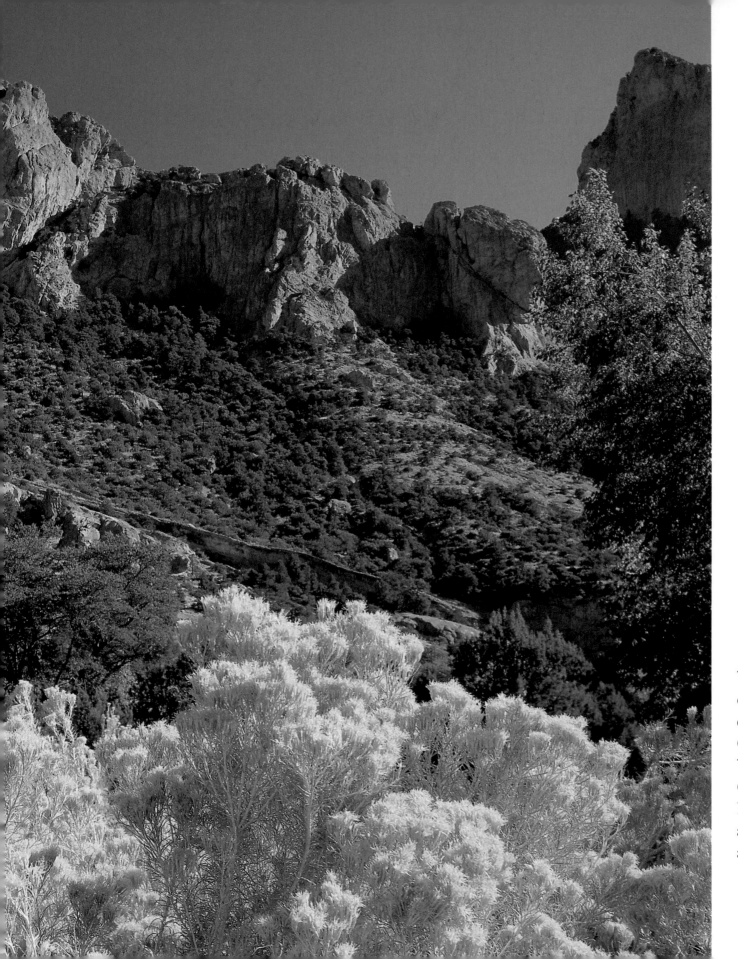

The yellow blooms
of rabbit brush
carpet Cave Creek
Canyon in the fall.
The canyon is part of
Coronado National
Forest, a 1.7-million-
acre preserve in the
areas around Tucson.

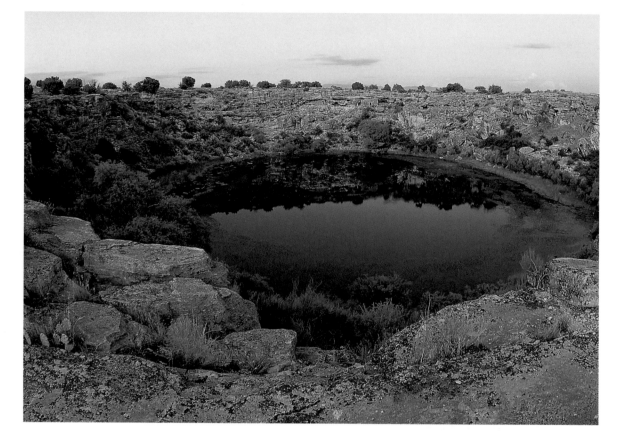

More than 50 feet deep, Montezuma Well is a natural limestone sinkhole, surrounded by ancient cliff dwellings.

Erroneously believed to be the palace of an Aztec ruler, Montezuma Castle was actually built by the Sinagua in the 12th century. The dwelling was five stories tall and boasted twenty rooms.

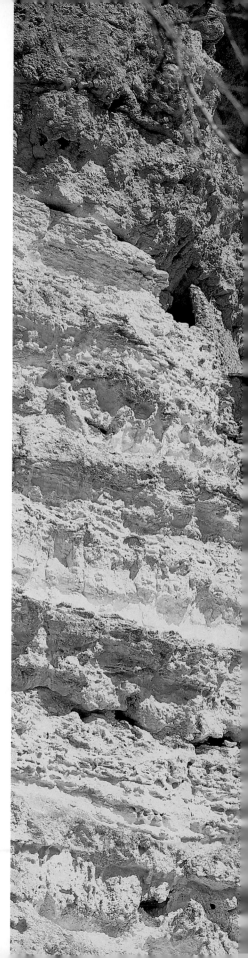

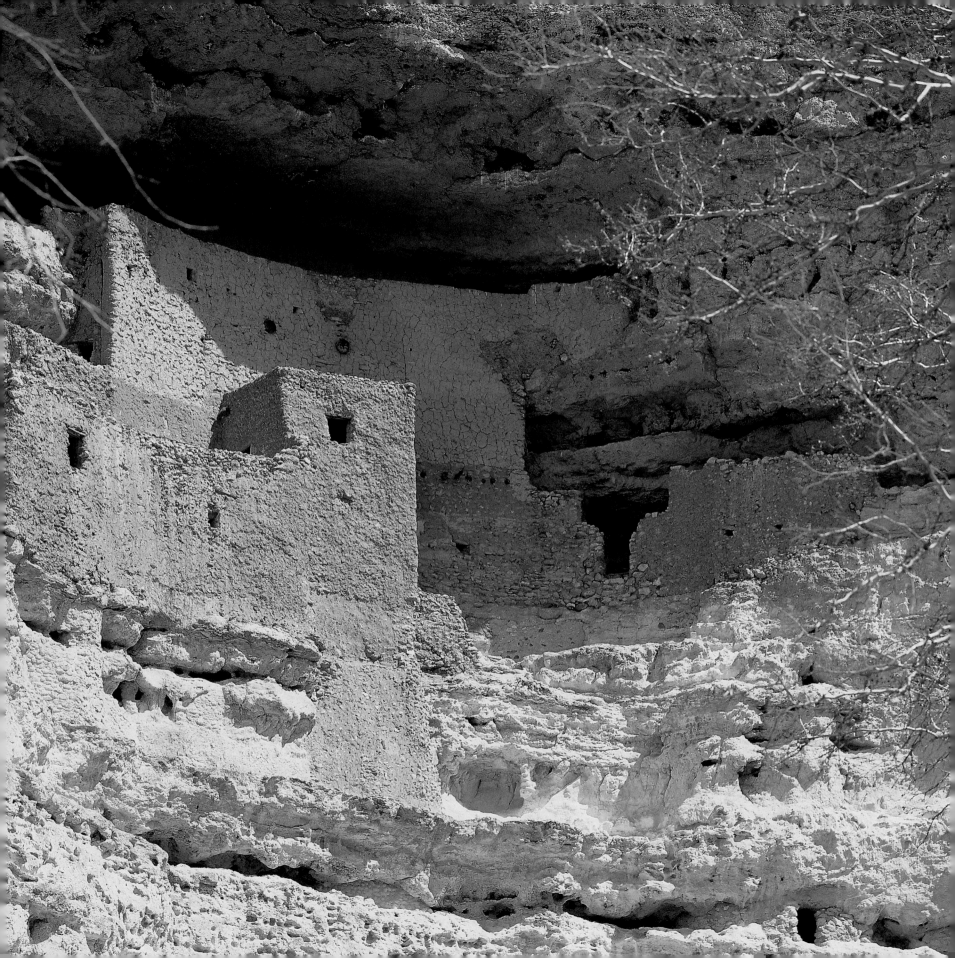

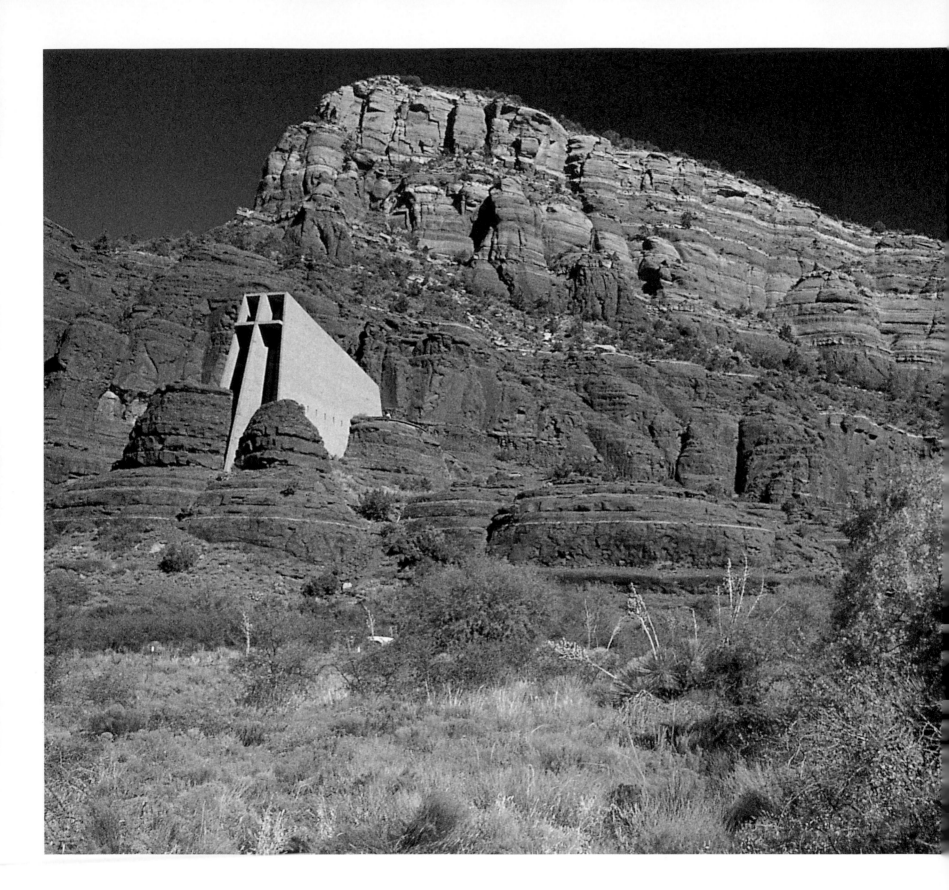

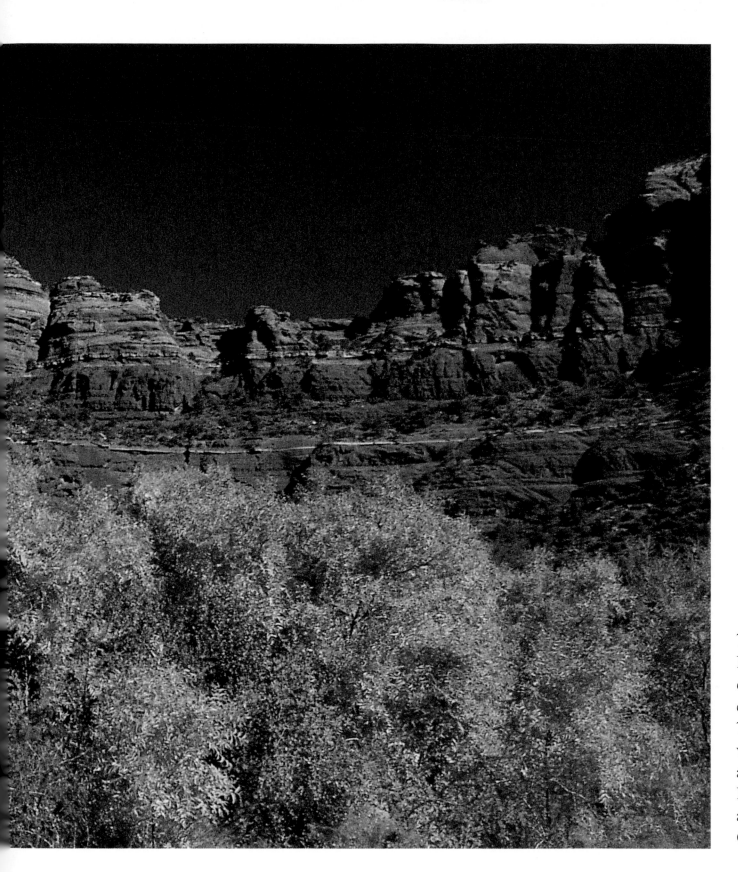

The Chapel of the Holy Cross is built of the red rock so common in Sedona. The striking retreat was designed by architect Marguerite Brunswig Staude and belongs to the Catholic Church.

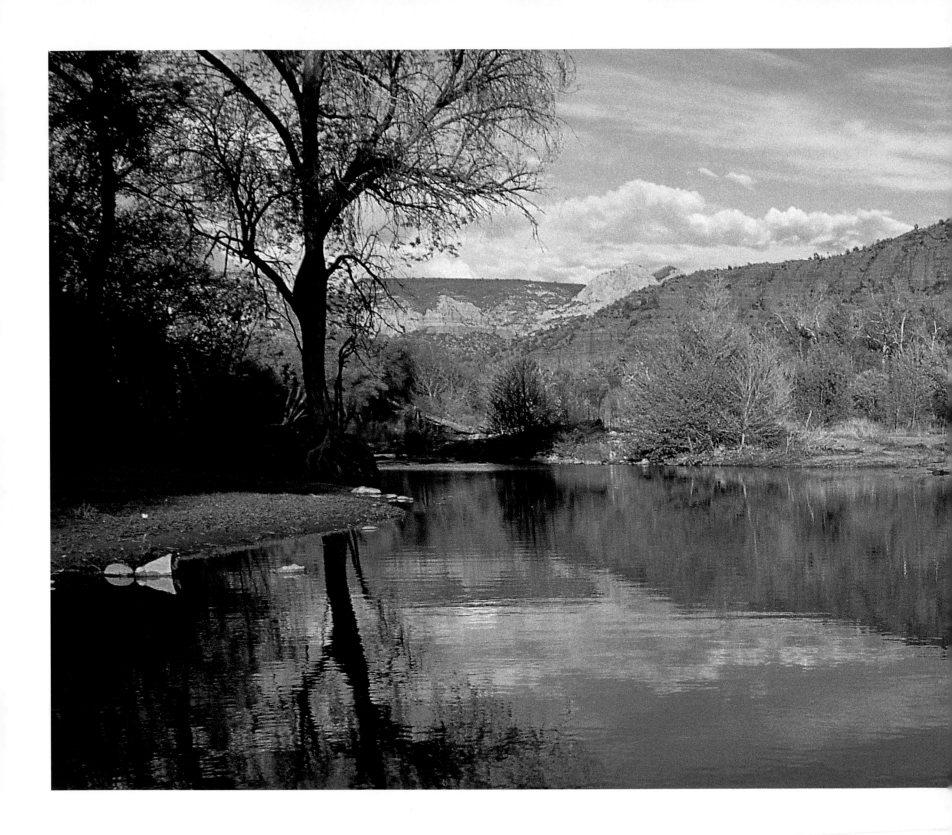

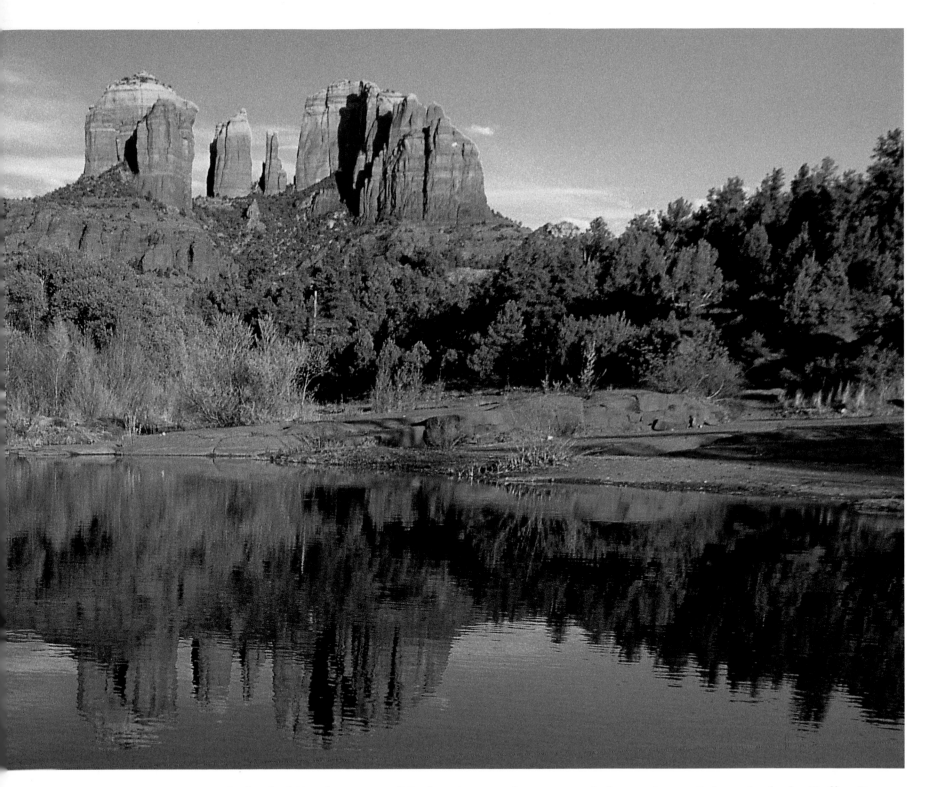

Cathedral Rock is one of Sedona's most famous rock formations. Others include Coffee Pot, Chimney, and Snoopy rocks. The rocks take on different shades of red depending on the time of day, and a growing number of enthusiasts believe they hold spiritual energy.

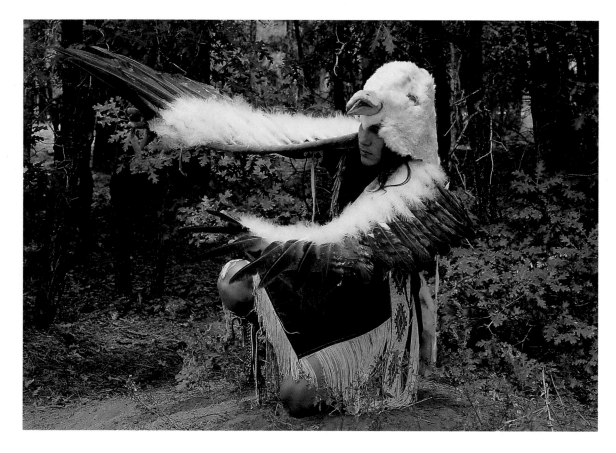

A young eagle dancer performs in a Navajo festival at Flagstaff's Museum of North Arizona. As well as displays of native art and artifacts, the museum offers information about the area's geography and ecology.

Home to 1,500 animals, birds, and plants, the Boyce Thompson Southwestern Arboretum was created to research desert species. Mining executive and philanthropist William Boyce Thompson founded the arboretum in the early 1900s.

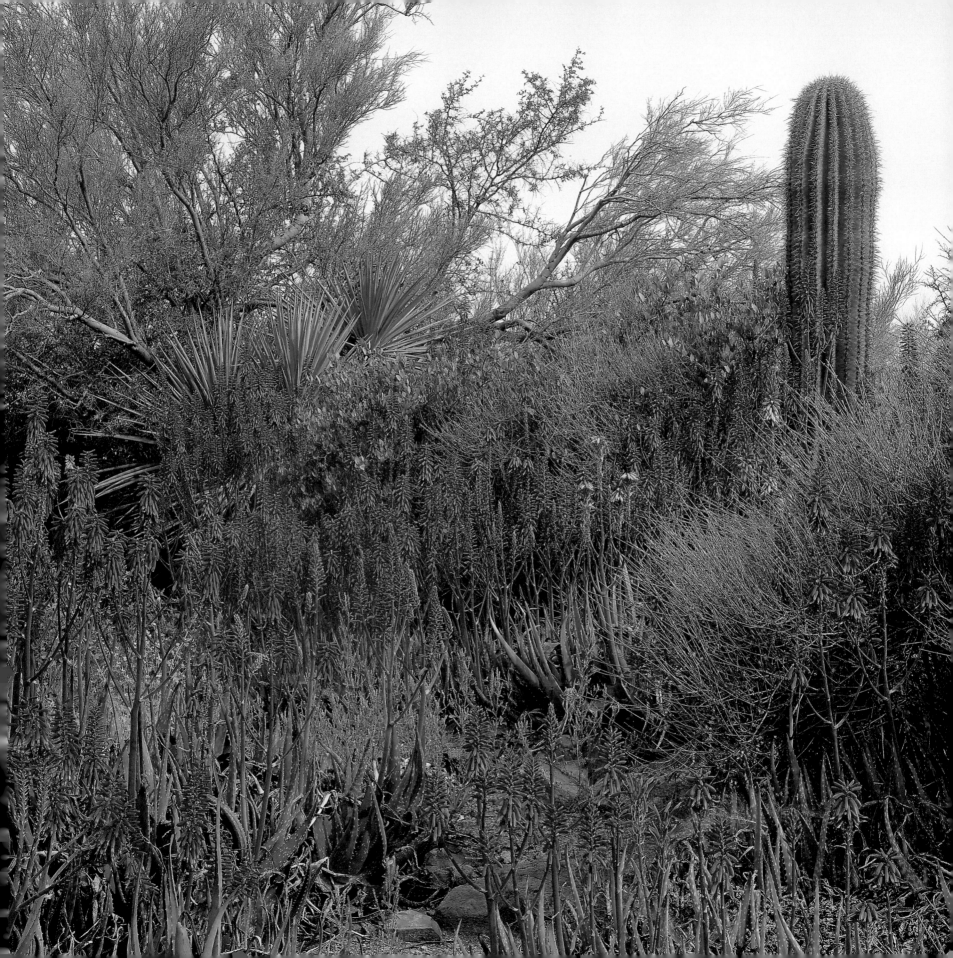

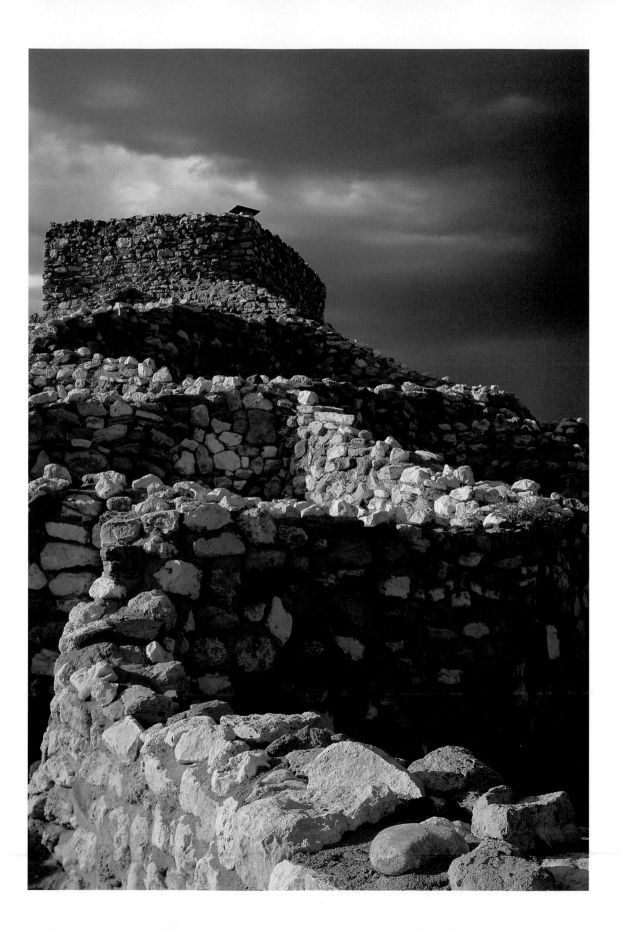

With 110 rooms, Tuzigoot National Monument once housed more than 200 people. The ruins are estimated to be 600 to 900 years old.

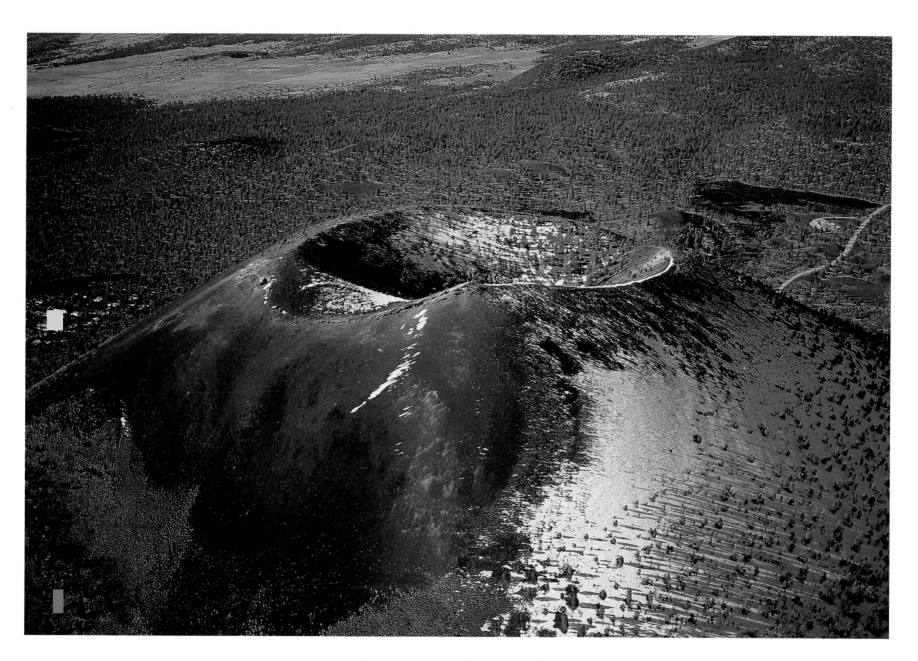

The barren landscape of Sunset Crater National Monument was created by volcanic eruptions, the last one about 700 years ago. Ash from these eruptions has coated the surrounding countryside, forming a rich agricultural region.

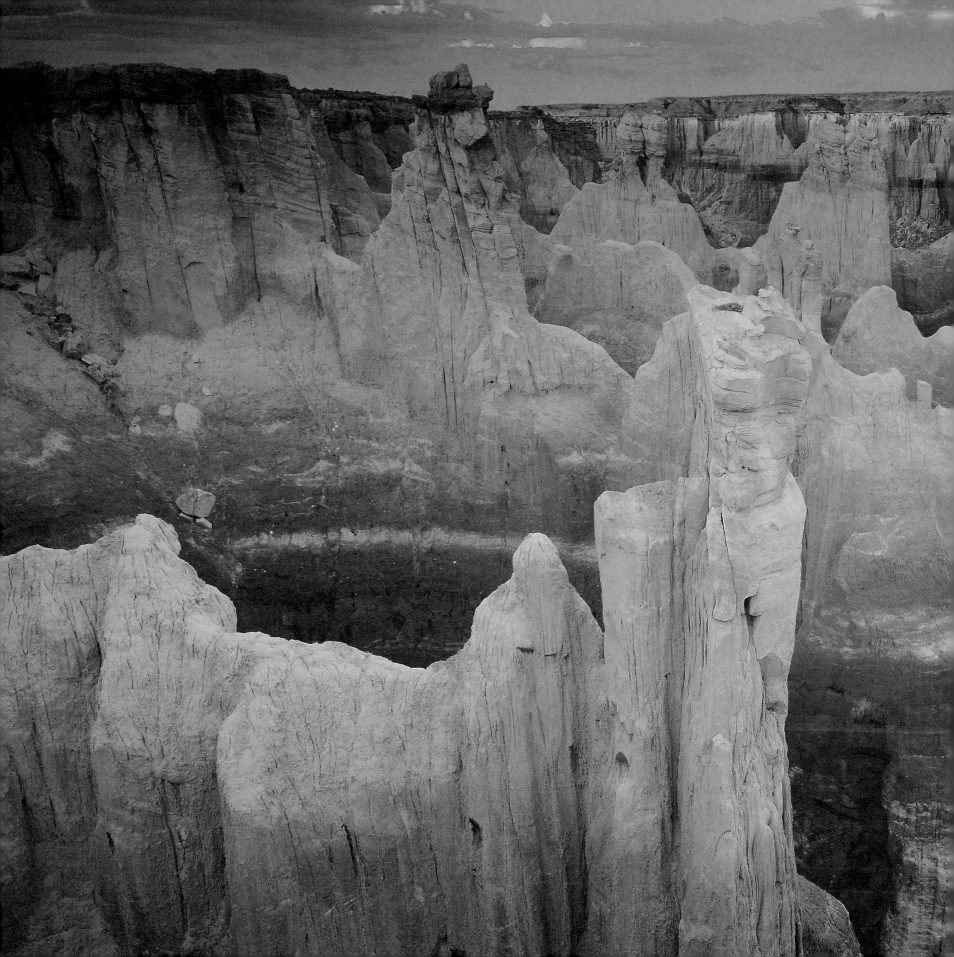

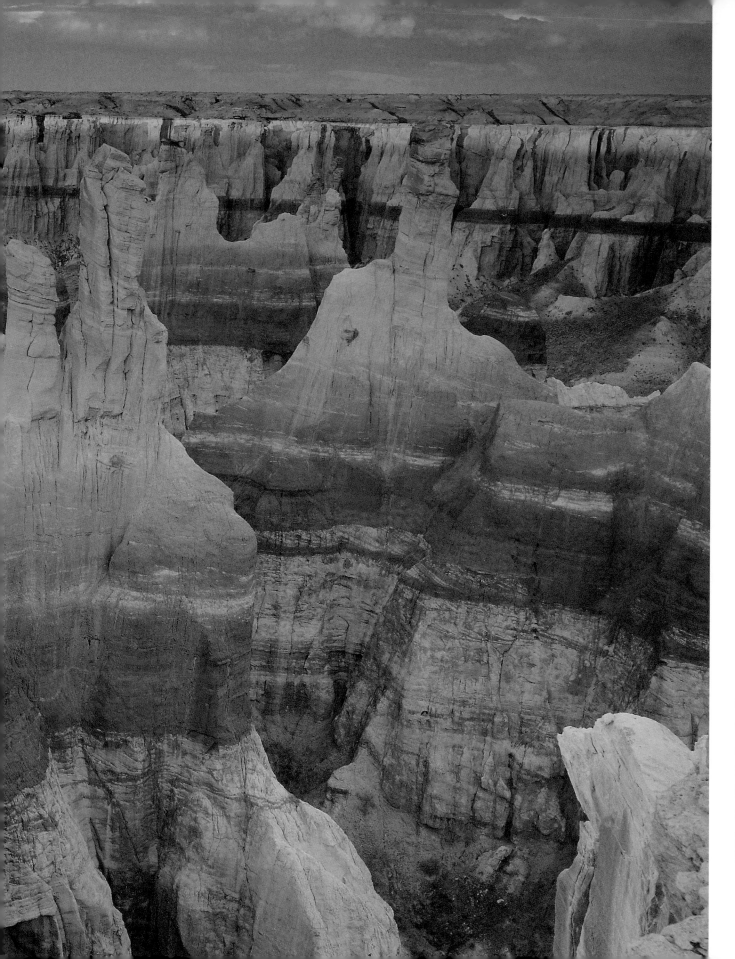

Coal Mine Canyon was saved from development by the poor quality of its coal. Its dramatic spires are now protected by a Navajo tribal park.

Once a single mountain, the San Francisco Peaks were created by a
volcanic eruption millions of years ago. Humphries Peak is the tallest
in Arizona, reaching 12,643 feet.

A spring storm rises over Ives Mesa in the Painted
Desert. Part of the Navajo Indian Reservation, the
badlands are streaked red, gray, and white—the
result of ancient volcanic activity.

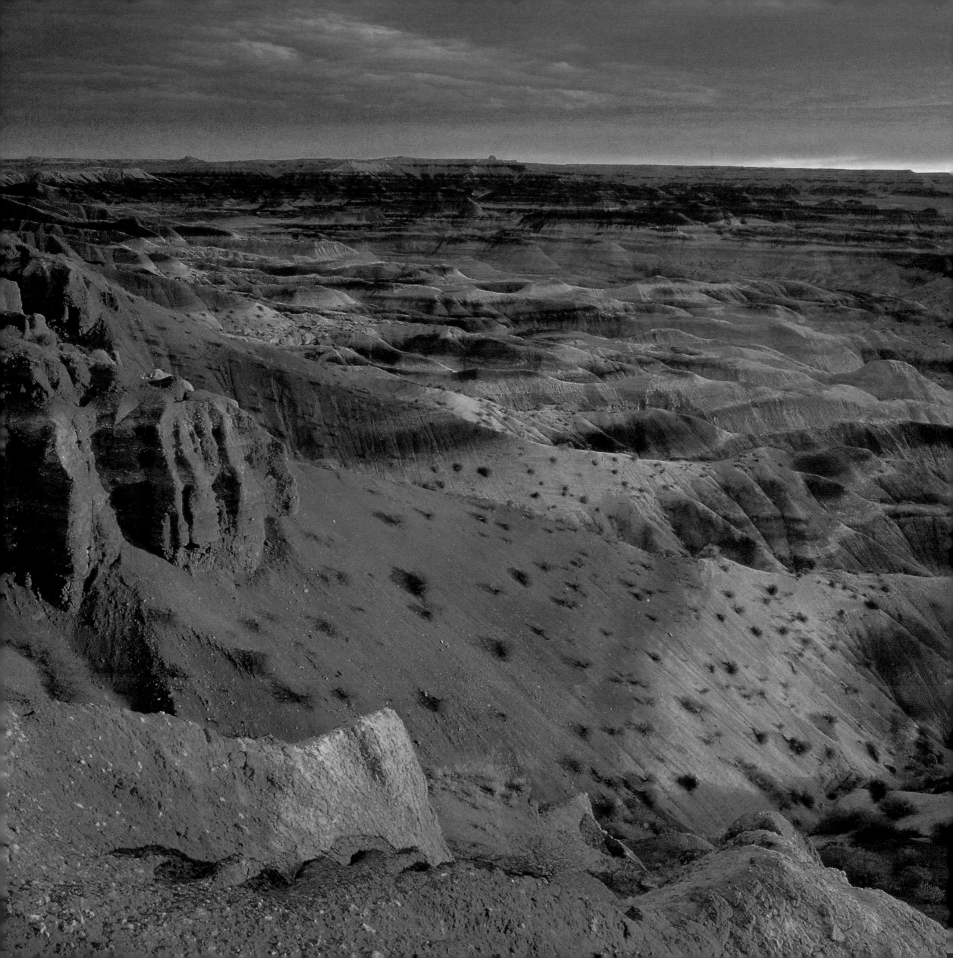

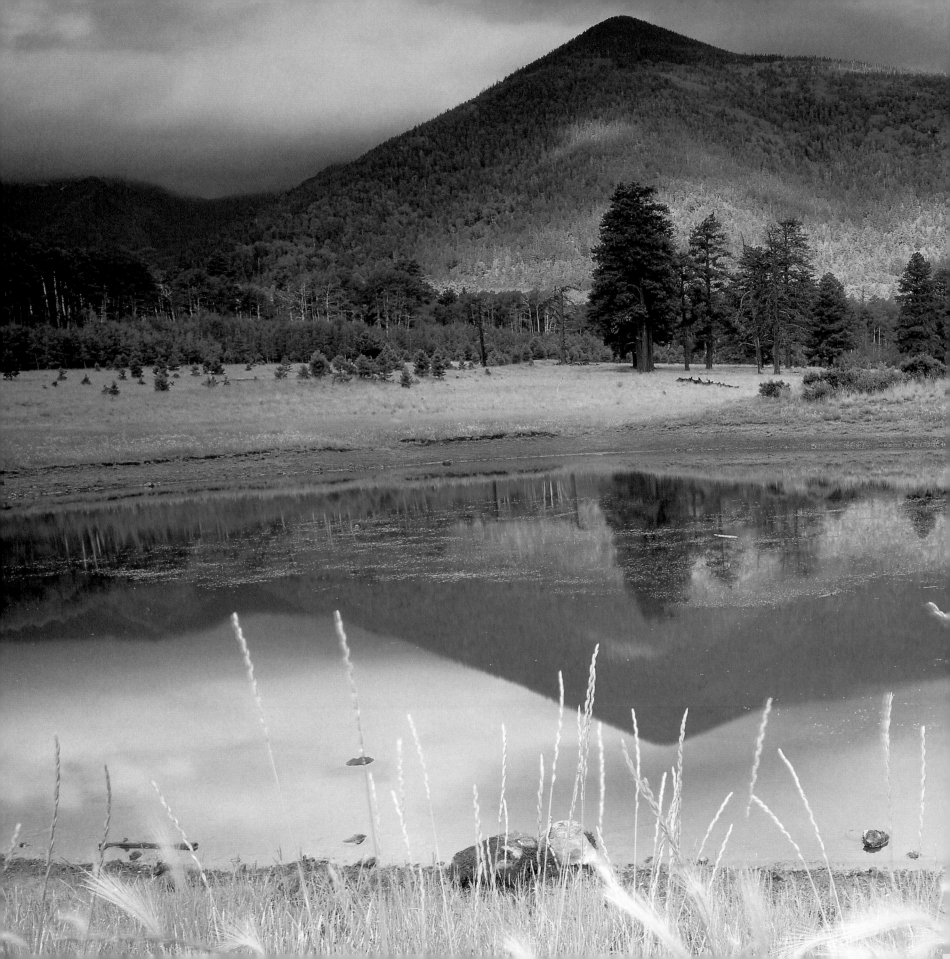

The San Francisco Peaks were named after St. Francis of Assisi by missionaries in the 17th century. These peaks are sacred to the Navajo, and mark the western boundary of their traditional lands.

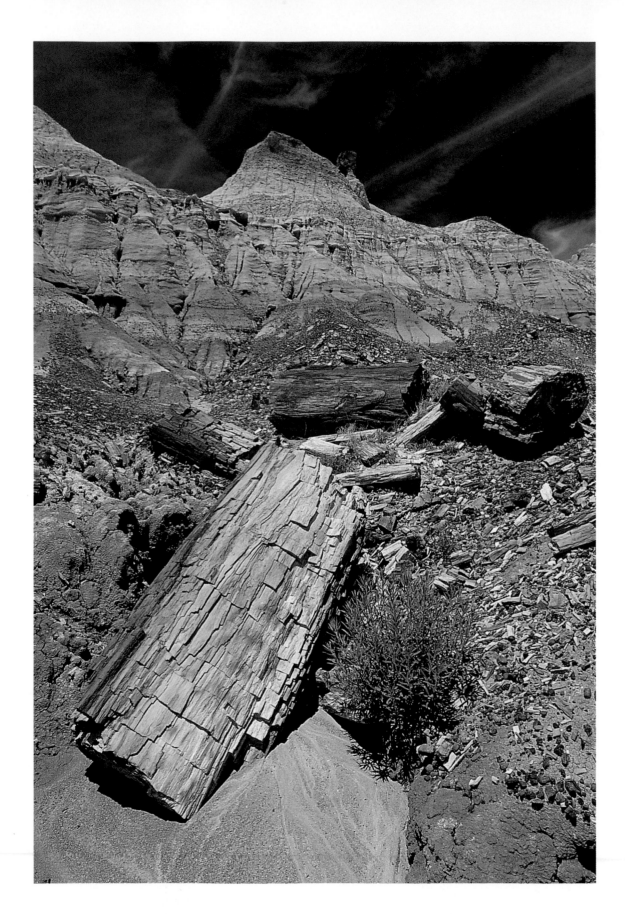

A combination of
volcanic ash and flood-
water created the Petrified
Forest—the world's largest
collection of petrified
wood—millions of years
ago. A 93,533-acre national
park has protected the
stone-like logs since 1906.

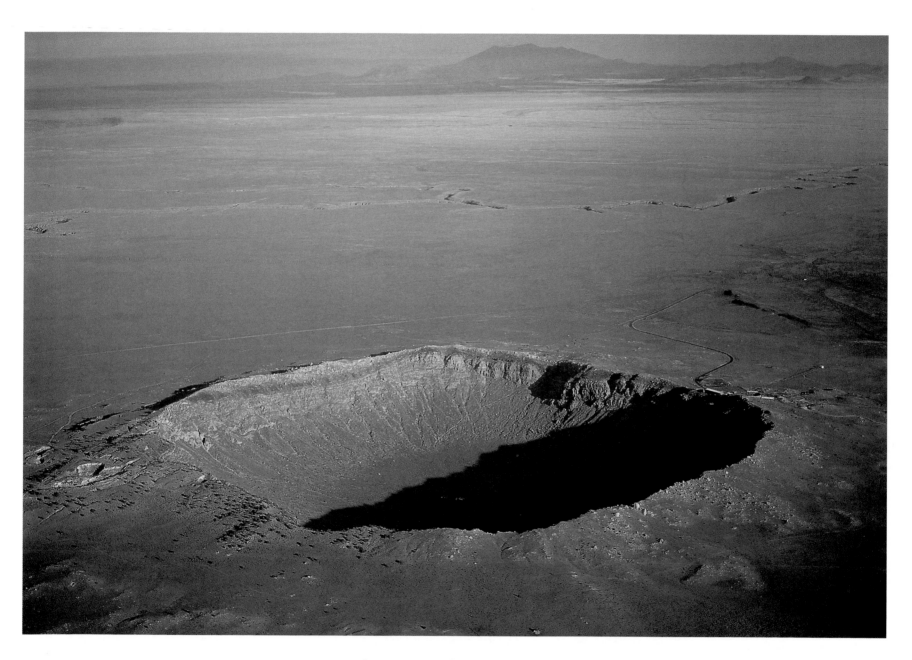

About 4,000 feet wide, the Meteor Crater east of Flagstaff was created about 50,000 years ago when a 100-foot meteor crashed to earth. The amazingly well-preserved crater is used by astronauts during training exercises.

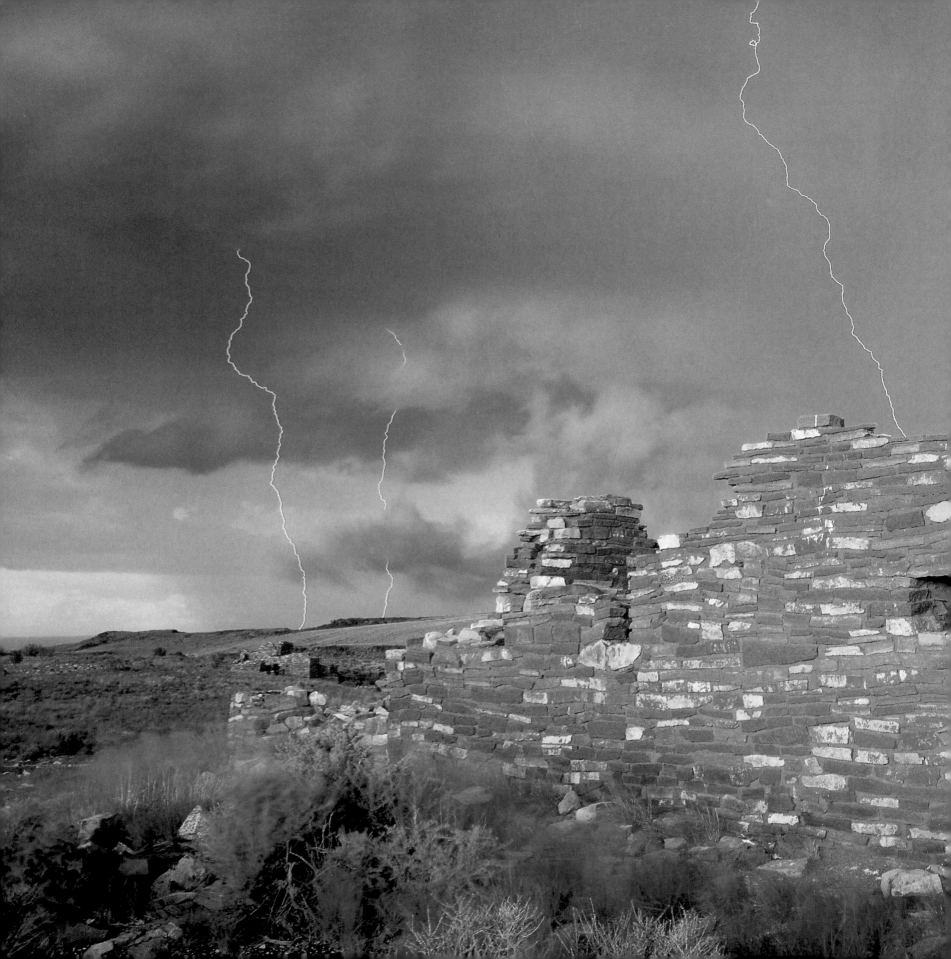

Scientists estimate
that up to 2,000
ruins, built from A.D.
1100 to A.D. 1300,
may be hidden in
the earth of Wupatki
National Monument.
Only a few have
been excavated.

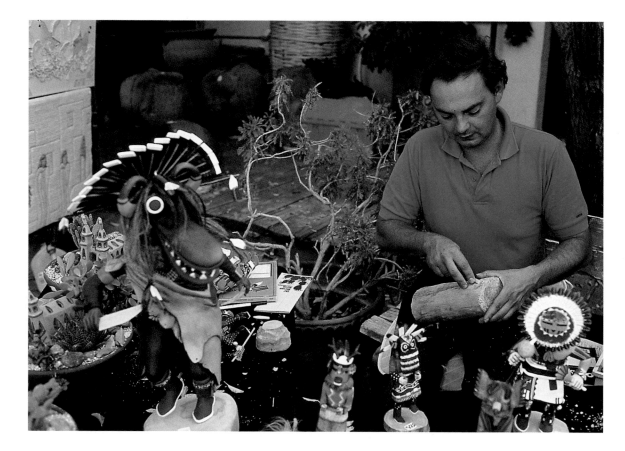

Traditionally carved from cottonwood root by the Hopi people,
Kachina dolls represent the spirits that bring rain to the earth.
They have become a popular souvenir for visitors to the Southwest.

Lorenzo Hubbell bought a trading post in 1876
and proceeded to make his fortune from wool.
Hubbell's Trading Post continues to operate,
now as a nonprofit National Historic Site.

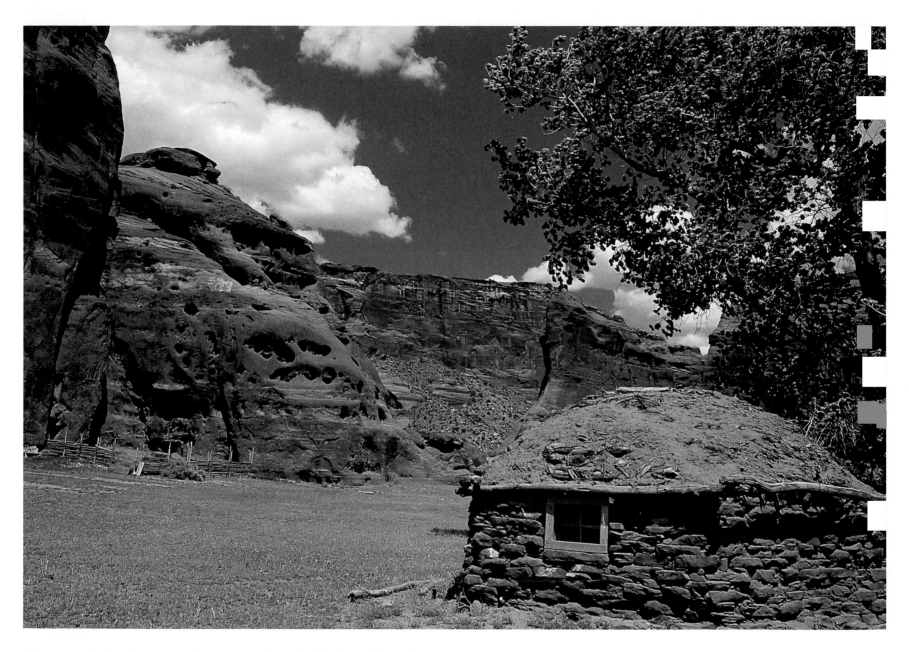

Canyon del Muerto and Canyon de Chelly have been home to Navajo people since the 18th century. Living in traditional log houses called hogans, the Navajo farmed the canyon bottoms.

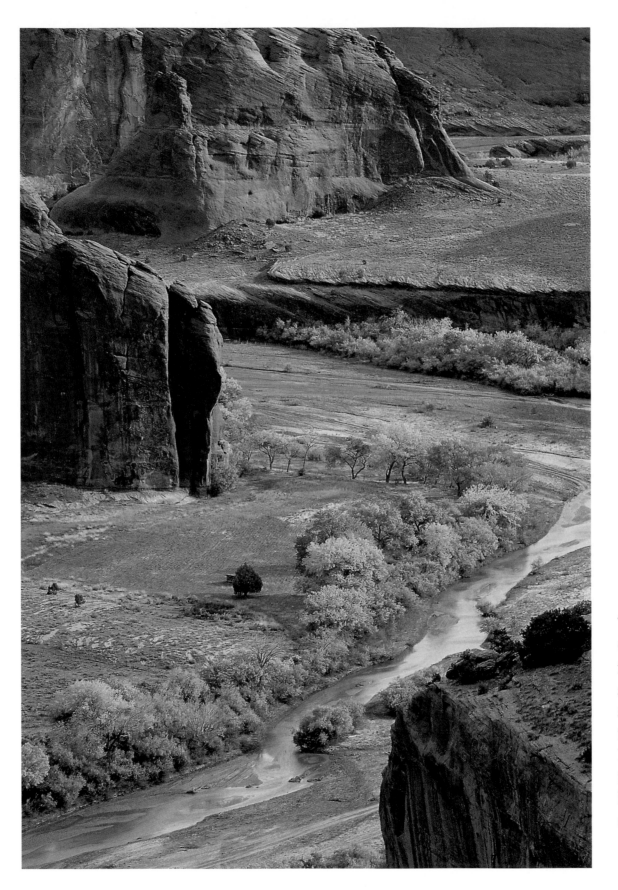

The river that carved Canyon de Chelly in the multi-hued sandstone supports a lush variety of life in the canyon bottom. In fact, the Navajo tended orchards here in the 18th and 19th centuries.

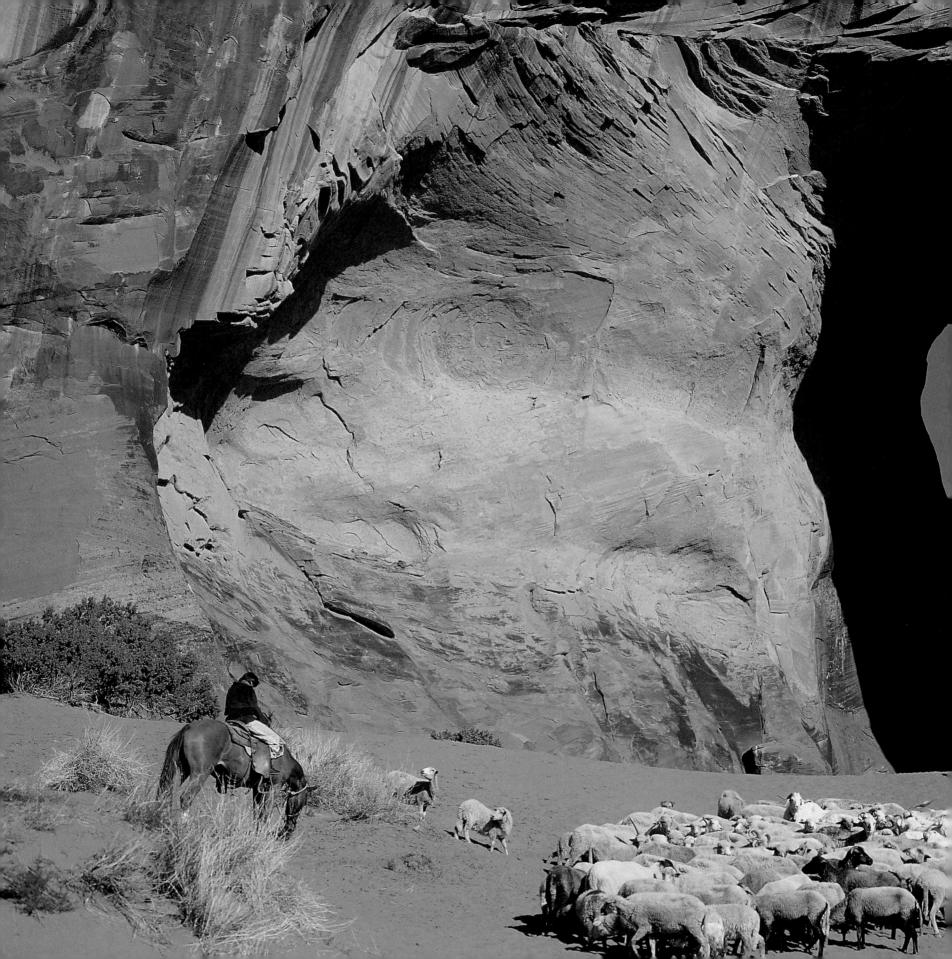

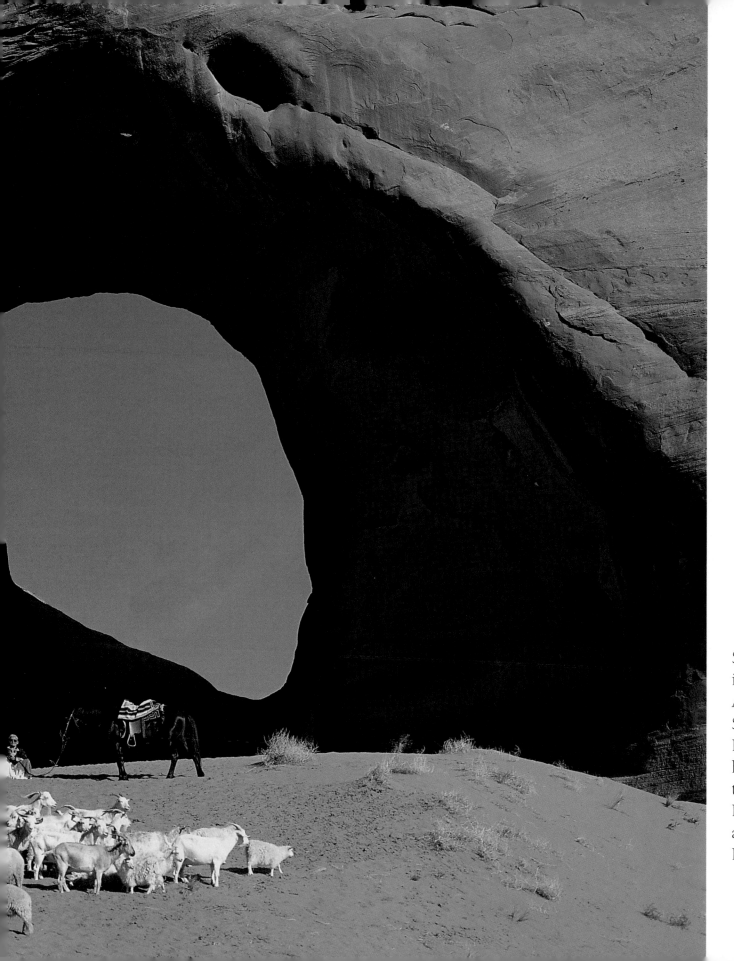

Sheep were introduced to North America by the Spanish, and the Navajo people have herded sheep since the 17th century. Mutton is traditionally a large part of the Navajo diet.

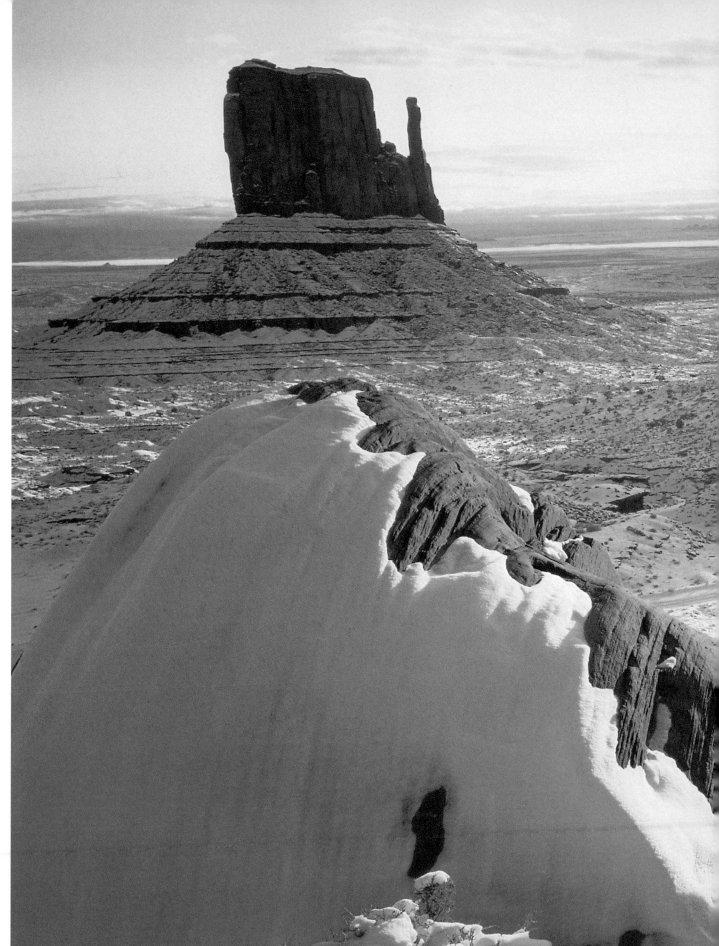

Monument Valley
Navajo Tribal Park
extends for 30,000
acres across the
Arizona-Utah border.
Created in 1958,
this was the first
Navajo Tribal Park.

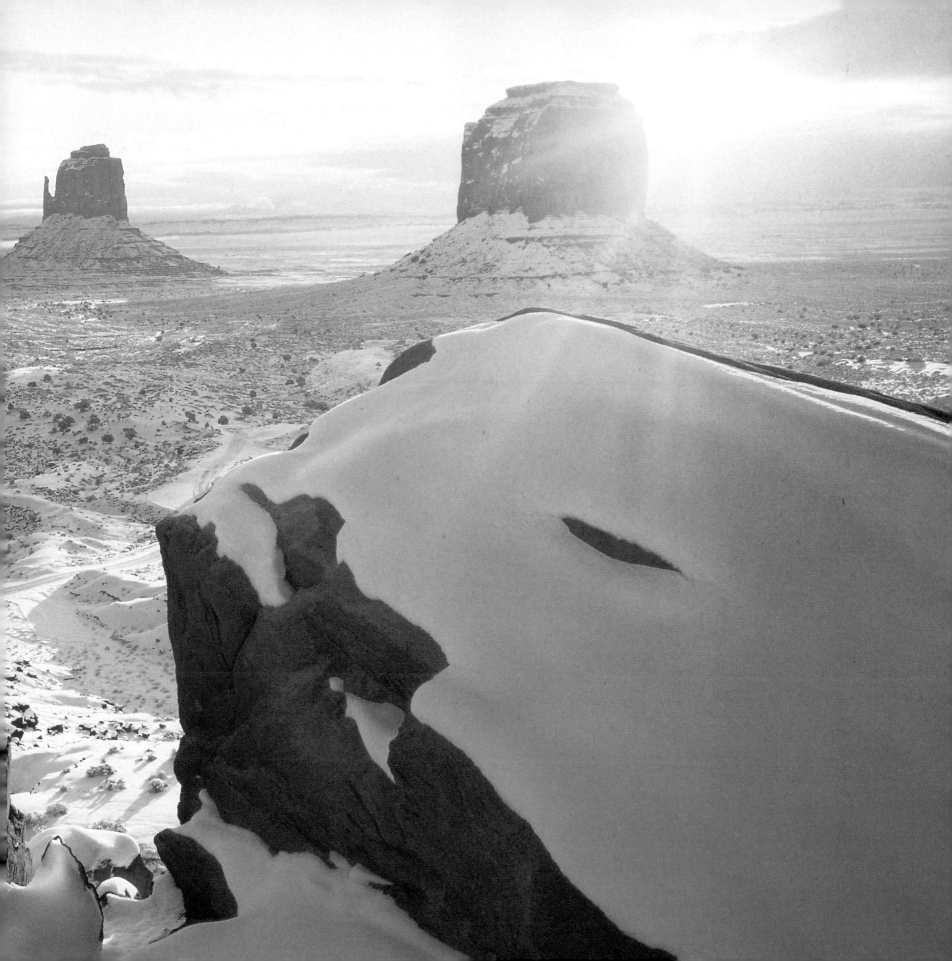

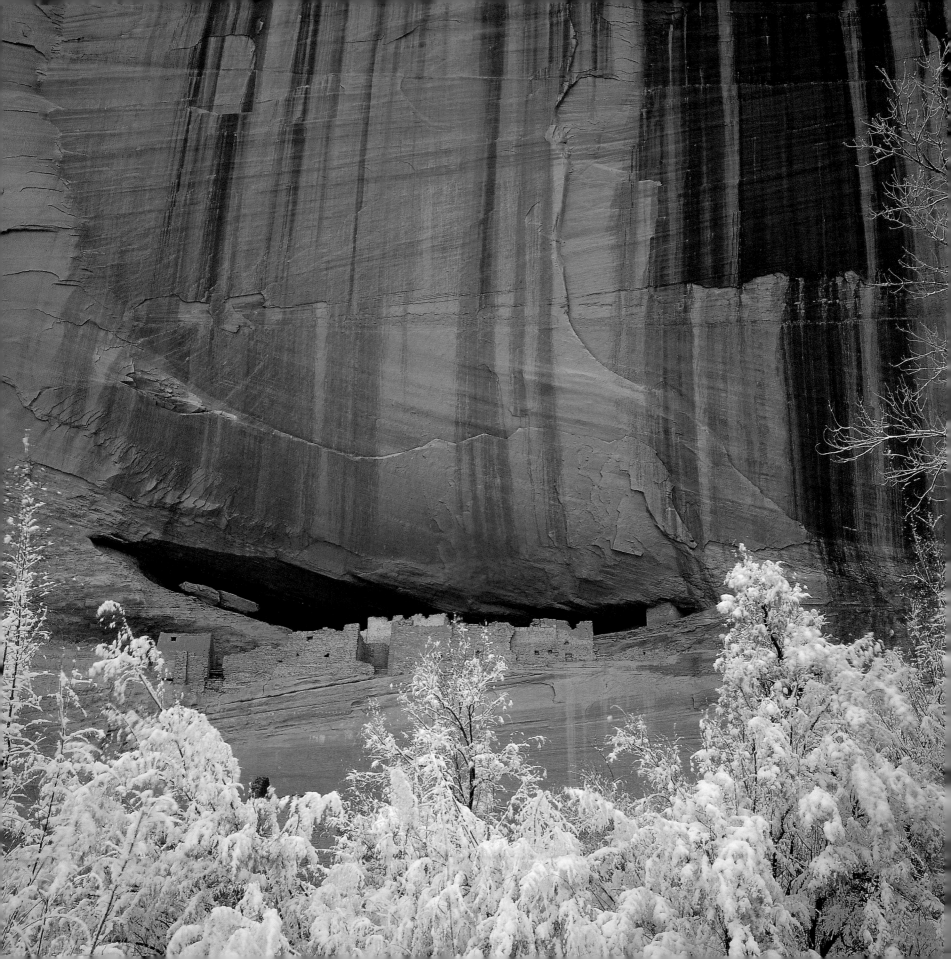

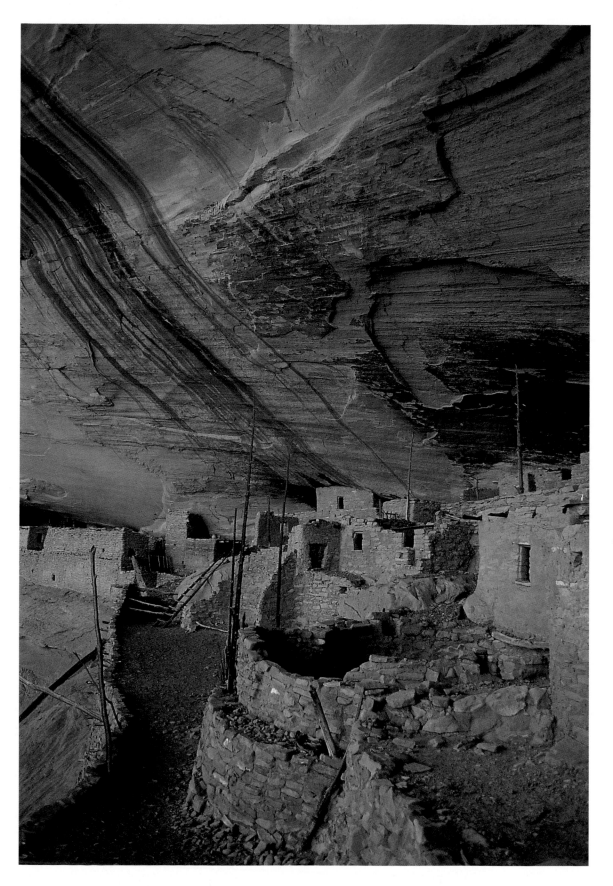

Part of the Navajo National Monument, the Keet Seel Ruins were occupied more than 1,000 years ago. They were preserved after trader and guide John Wetherill discovered them in 1933.

OPPOSITE —
At the base of a 500-foot cliff, White House Ruin was once home to about 100 people. It has been protected by Canyon de Chelly National Monument since 1931.

The Safford area is home to a number of cotton farms, but this particular field has been plowed to grow food for the animal residents of Cluff Ranch Wildlife Area.

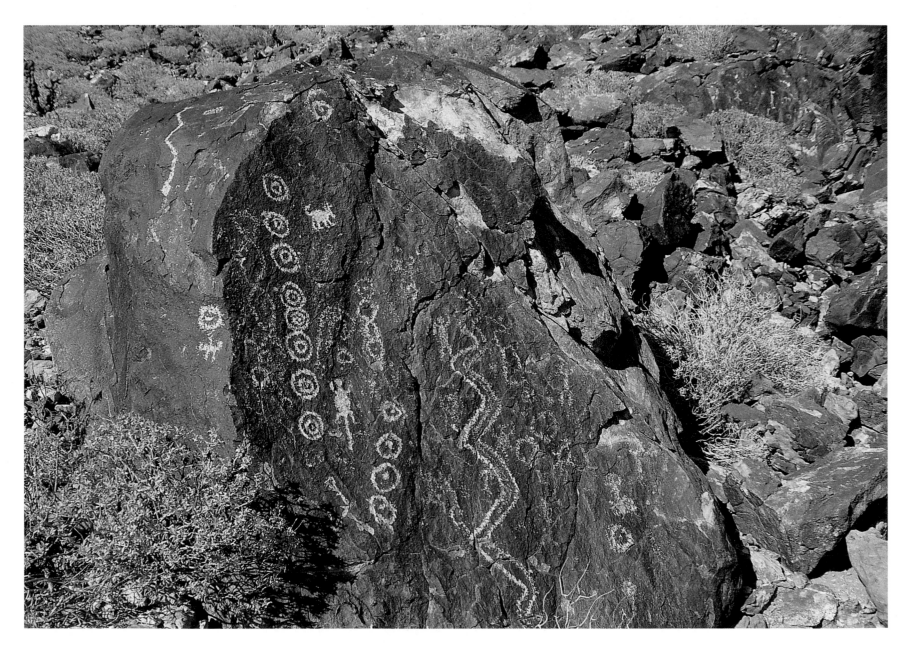

Tens of thousands of petroglyphs can be found throughout the
Southwest, protected by cliff overhangs and canyons and preserved
by the dry desert air. Some were chiseled up to 3,000 years ago.

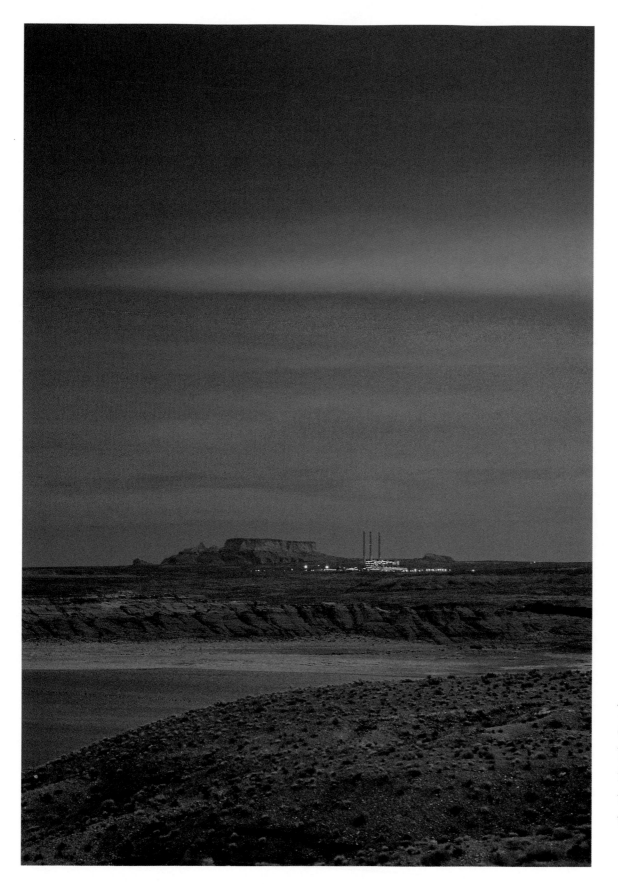

The Navajo
Generating Station in
Page produces power
from the millions of
tons of coal mined in
the state each year.

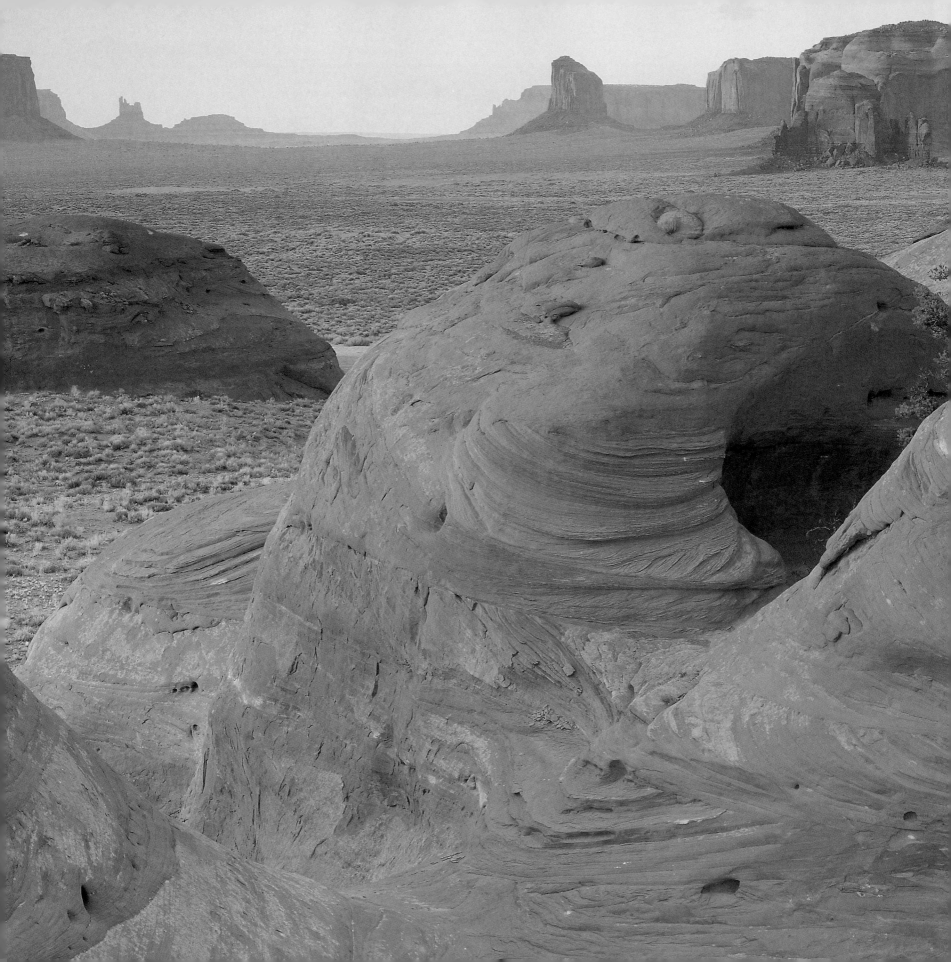

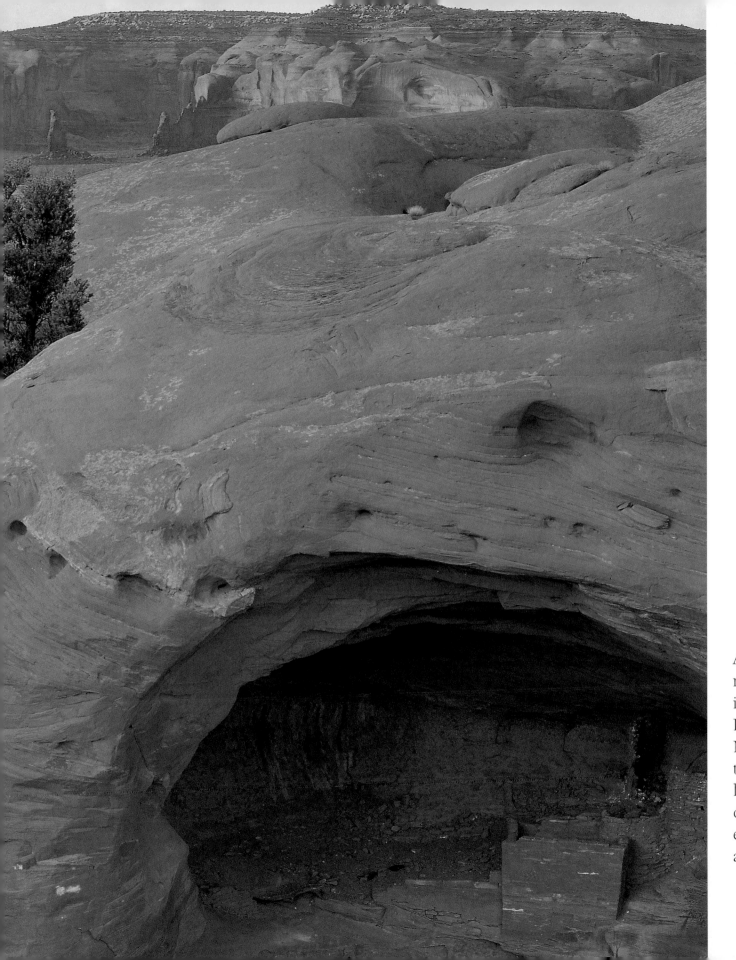

Arizona has the largest native population in the United States. During World War II, Navajo radio operators used their native language as a code— one which the enemy was never able to break.

Photo Credits